RAPHAEL & THE
POPE'S LIBRARIAN

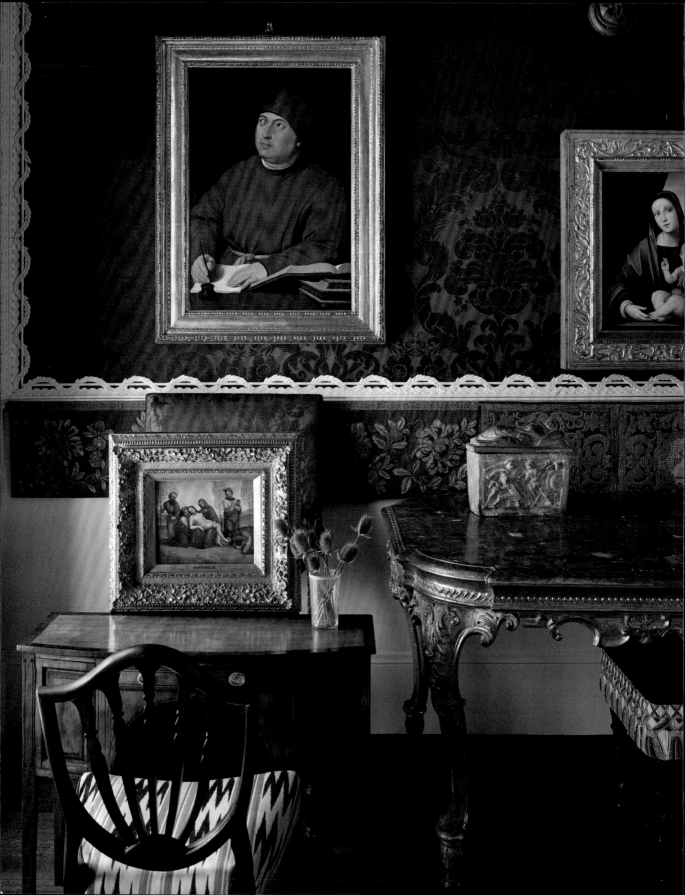

RAPHAEL & THE POPE'S LIBRARIAN

EDITED BY

Nathaniel Silver

ISABELLA STEWART GARDNER MUSEUM, BOSTON
PAUL HOLBERTON PUBLISHING, LONDON
2019

First published to accompany the exhibition

RAPHAEL & THE
POPE'S LIBRARIAN

Curated by Nathaniel Silver

31 October 2019 – 30 January 2020

Raphael & the Pope's Librarian is part of the Close Up exhibition series that has been generously sponsored by Fredericka and Howard Stevenson. The museum is also supported by the Massachusetts Cultural Council, which receives funding from the State of Massachusetts and the National Endowment for the Arts.

ISBN 978 1 911300 76 2

Produced by Paul Holberton Publishing
89 Borough High Street, London SE1 1NL
WWW.PAULHOLBERTON.COM

Designed by Laura Parker
Printing by Gomer Press

Cover: Raphael, *Tommaso Inghirami*, about 1510 (detail, fig. 24)

Back cover: Tommaso Inghirami, Commentary on 'The Art of Poetry' by Horace, cover, about 1515–16 (fig. 38)

Page 2: Raphael Room, Isabella Stewart Gardner Museum, Boston

Page 53: Isabella Stewart Gardner, Travel Album: Italy, France, and Great Britain, page 33, 1886. Isabella Stewart Gardner Museum, Boston

Page 63: "Latest Whim of America's Most Fascinating Widow," *New York Journal and Advertiser*, 1889. Isabella Stewart Gardner Museum, Boston

Contents

Director's Foreword

In 1898, Isabella Stewart Gardner brought the first painting by Raphael to America. It was one of many highlights during a year of intense acquisition and momentous occasion. By December, Gardner had purchased the land in Boston's Fenway for her nascent museum and began to deliberate over the installation of her collection. The portrait of *Tommaso Inghirami* inspired her to name a gallery after Raphael, characterized by one of Isabella's friends as her "favorite room" in Fenway Court. Gardner subsequently bought two more works by Raphael, a spectacular coup for any collector.

This third installment of our celebrated *Close Up* series commemorates the five hundredth anniversary of Raphael's death in 1520. The exhibition and its publication tell two stories. The first sheds new light on Gardner's acquisition of *Tommaso Inghirami* and its journey to Boston. The second brings to life the man in the picture, exploring the fascinating career of this Vatican librarian and his friendship with Raphael. I would like to thank Barbara Jatta, Director of the Musei Vaticani, Guido Cornini, that museum's Curator of 15th and 16th Century Art, and the *capitolo* of the Basilica San Giovanni in Laterano for making possible another Raphael debut in this country, the generous loan of Raphael's ex-voto *Tommaso Inghirami Fallen under an Ox-Cart in Rome*. Together these works celebrate the long-standing taste for his paintings in America and the spirit of collaboration fostered by our founder. I am extremely grateful to Nathaniel Silver for organizing the exhibition and writing much of this book.

PEGGY FOGELMAN
Norma Jean Calderwood Director

Acknowledgments

Over one hundred years later, this exhibition celebrates Gardner's legendary acquisition of *Tommaso Inghirami* and shares his story with our audiences. First and foremost, I would like to thank Peggy Fogelman, Norma Jean Calderwood Director, for her generous support of this project. Gianfranco Pocobene, Chief Research and Paintings Conservator, carefully cleaned this portrait and retouched several abrasions, including across the sitter's proper left eye. I am especially grateful to Elizabeth Reluga, Head of Collections Access, who managed the publication of this book with a deft hand and whose thoughtful suggestions improved its texts immeasurably. Molly Phelps, Collection Cataloguer and Administrator, tracked down the early photograph of Bernard Berenson in the Sylvia Sprigge papers at Harvard's Houghton Library. Shana McKenna, Archivist, assisted me with several research queries within the museum's archive. Fronia Simpson gave the text her characteristically meticulous attention and, on her final project with us, we extend to her our profound gratitude for so many happy collaborations over the last six years.

At the Gallerie degli Uffizi, director Eike Schmidt and curators Anna Bisceglia, Francesca De Luca, and Alessandra Griffo made it possible for myself and Gianfranco Pocobene to examine the Galleria Palatina version of this portrait up close and before museum opening hours. Elsewhere in Florence, I benefited from the wisdom of Ilaria Della Monica and Giovanni Pagliarulo at Harvard's Villa I Tatti, the research assistance of Maximillian Hernandez at the Kunsthistoriches Institut, and the sound advice and good humor of his supervisor Jessica Richardson. In Volterra, Jacopo Inghirami generously gave me access to his family palazzo and shared personal insights into his ancestor's biography. Friends and colleagues Joseph Connors, Yvone Elet, Claudia Montuschi, Louise Rice, and Christa Gardner von Teuffel weighed in at different points of my journey along the Inghirami trail and I thank them all for their gracious generosity and valuable advice. Finally I am extremely grateful to my co-author Ingrid Rowland whose profound knowledge of Roman antiquity and high Renaissance humanism brought this era to life. Her tremendous enthusiasm for all things Inghirami knows no bounds. For those interested in further reading on Inghirami's portrait by Raphael, a recent discussion can be found in catalogue of the 2016/17 exhibition *Orlando Furioso 500 anni. Cosa vedeva Ariosto quando chiudeva gli occhi*, at which the Florence version was displayed.

I dedicate this book to my wife Caroline, whose tremendous patience made possible the travel and research for this exhibition, and to our tiny rhinoceros Theo who grows bigger every day.

NATHANIEL SILVER
William and Lia Poorvu Curator of the Collection

The Question of Attribution

NATHANIEL SILVER

The portrait of Tommaso Inghirami by Raphael at the Isabella Stewart Gardner Museum is one of two versions; the other is in the collection of the Galleria Palatina, Palazzo Pitti, Florence (fig. 1). The attributions of these paintings have been a matter of debate for more than a century. When Gardner purchased her painting in 1898, its attribution to Raphael had been made by the Italian connoisseur Giovanni Morelli, championed by the art historian Bernard Berenson, and was supported by the majority of scholars, who saw the portrait in the Pitti as a copy. During the course of the twentieth century, the scholarly consensus shifted in favor of the Pitti portrait.

In a 1996 article, Giovanni Batistini published several seventeenth-century documents from the Inghirami family archive that raised questions regarding the relation of the two portraits and their provenance. The new evidence concerned the family inheritance and testimony from lawsuits among several descendants, one of which claimed that a member of the Inghirami family consigned or gave the portrait of Tommaso to Prince Leopoldo de' Medici of Florence, in whose collection it is first recorded between 1663 and 1666 and through whom it became part of the Galleria Palatina. If true, this would make the Gardner version a seventeenth-century copy of the portrait made for the Inghirami family. However, the testimony is contradictory and the evidence incomplete. It is not known if the claim is accurate and even if the transfer was ever carried out.

In a postscript to the story, the painter Ignazio Zotti is documented as having cleaned the Inghirami family's "portrait of Fedra Inghirami by Raphael" in 1857. One year later he made a copy of the Gardner painting, which remains today in the Palazzo Inghirami in Volterra (fig. 2). Other nineteenth-century copies exist as well.

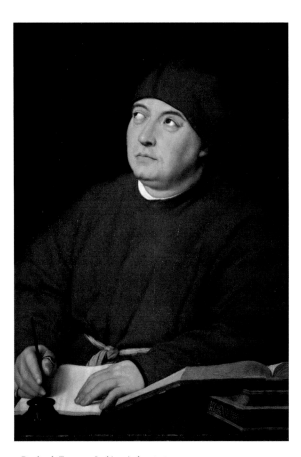

1. Raphael, *Tommaso Inghirami*, about 1510. Oil on panel, 90 × 62 cm. Galleria Palatina, Palazzo Pitti, Florence

2. Palazzo Inghirami, Volterra

The relationship between the Gardner and Pitti versions of the portrait remains unclear. Comparison of the results of technical analyses conducted in Cambridge and Florence respectively, suggests that the two paintings are very similar. While the condition of the Boston version is unquestionably poorer than that of its counterpart in Florence, especially in the loss of oil glazes across the sitter's body, its materials and construction are consistent with those of the sixteenth century, and its execution is in keeping with that of Raphael's work.

Why would Raphael have produced two versions of the same portrait? Perhaps he painted one for his employer, Pope Julius II, and the other for Tommaso or the Inghirami family. In 1842 a descendant outlined this scenario in a text that accompanied an engraving of the painting in the Galleria Palatina. He claimed that Pope Leo X commissioned the portrait from Raphael and also gave a copy to the Inghirami family. His account might well have been based on family tradition, or it may be a complete invention. Equally, Tommaso himself may have commissioned one for the pope and another for his family. Either scenario could, hypothetically, explain the existence of two contemporaneous versions. With documents unlikely to shed further light on the matter, this question awaits the opportunity for both paintings to come together and to be assessed in a comparative technical analysis.

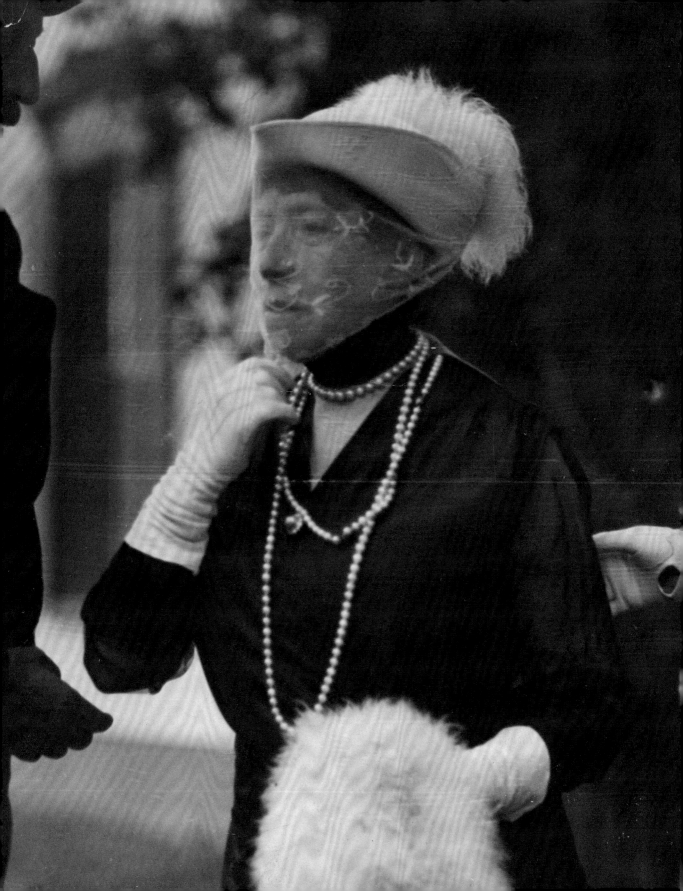

"I have tasted blood"
Isabella Stewart Gardner and the
First Raphael in America

NATHANIEL SILVER

Nearly five centuries after his death in 1520, Raphael's fame remains undiminished. Crowned "prince of painters" by Giorgio Vasari, he inspired both artists of his own time and others for centuries afterward. According to the celebrated writer Henry James, Raphael's work was "semi-sacred." Gilded Age American collectors swooned over his iconic religious images and masterly brushwork, and James's contemporaries feverishly tried and failed to acquire Raphael's rare paintings in a market flooded with copies, and the occasional forgery. Isabella Stewart Gardner (fig. 3) took up the challenge, determined to buy a magnificent Madonna by Raphael. Without the bottomless financial resources of her plutocrat peers like J. P. Morgan or Henry Clay Frick, she instead turned to a network of advisers and dealers who presented her with unique—or apparently unique—opportunities of first refusal. Yet her determination was as powerful as the demand for these rare paintings. As she wrote in 1902 to her longtime friend, the art historian Bernard Berenson (fig. 4), "My remaining pennies must go to the greatest Raphael. . . . I have tasted blood you see." The taste she referred to was three works she acquired by the master himself—two paintings and a drawing— but never a Madonna. This chapter tells the story of one of the two paintings. Following her gripping hunt, Gardner was the first collector to bring a work by Raphael to America, where its unexpected subject led to a mixed reception and generated surprising rumors in the years to follow.

The Gardners had been abroad for nearly half of 1897, traveling across France, England, and Germany,

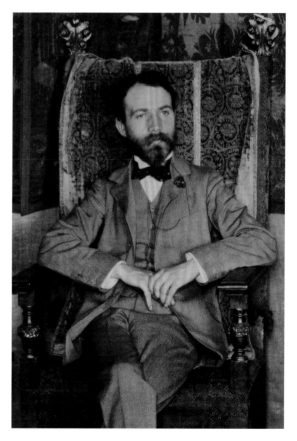

4. Edmund Houghton, Bernard Berenson at La Canovaia, 1898. Houghton Library, Harvard University

FACING
3. Isabella Stewart Gardner, about 1915.
Boston Public Library

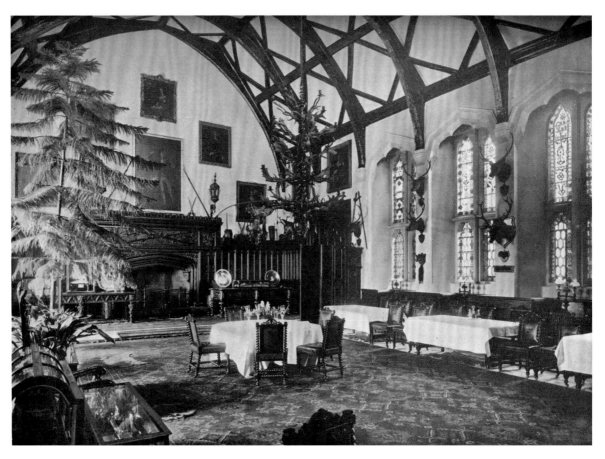

5. Berkeley Castle, Gloucestershire, 1900

when they returned to Boston on 23 December. The final month in Europe found them in the Gloucestershire countryside as guests at stately Berkeley Castle (fig. 5). What impressed Isabella the most were the rural sports, a fox hunt, whose members wore yellow rather than the customary pink (actually, red) jackets, and an "Awfully exciting" duck shoot that she described in great detail. Although Gardner found the castle a dreary pile— "the most middle age thing imaginable"—she adored its private chapel not least on account of the "Fancy, special indulgence granted by [Pope] Urban II." No doubt Gardner already had in mind a similar feature for her future museum. From England they continued on through Paris and prepared for the choppy voyage home, arriving in Boston just in time for Christmas.

Berenson himself was also on the move, but in Florence and from one house to another. The day after Christmas, he took possession of a house outside the city center called La Canovaia (5, Via di Camarata)— one of several accommodations he rented before eventually buying Villa I Tatti—and began redecorating it to suit his tastes. The young connoisseur and budding art dealer repainted his rooms a pistachio green, hanging the walls with old prints—gold-ground paintings were not yet in his price range—and draping rich damask textiles across the walls and furniture. For months Berenson's letters had followed the Gardners as they made their way across the Continent. Distance between them posed no obstacles to her ambitions, and Gardner continued to make acquisitions by

correspondence. Italian Renaissance pictures were a priority. The triumphs of 1897 included the magnificent *Saint George Slaying the Dragon* by Carlo Crivelli and *Christ Carrying the Cross*, then given to Giorgione (now attributed to the Circle of Giovanni Bellini, fig. 6), while she had passed over a Watteau in favor of a pair of Pesellino *cassoni*, nixed a pair of paintings by Greuze, and declined two Goyas.

Raphael had been a leitmotif of the correspondence even before Isabella and her husband went to Europe. Gardner pined for an iconic image of the Virgin Mary, like Lord Cowper's, a painting Berenson joked she would be lucky to get, were it ever available (it was not), for £50,000. Madonnas by Raphael were the ultimate trophy paintings of the Gilded Age: the most expensive genre by the era's most sought-after Italian Renaissance painter and an opportunity, even if one became available, well beyond her limited means. The most she had spent on a painting was £20,000, on Titian's *Rape of Europa* in 1896, and at her current rate of consumption she could not afford a repeat performance. In August 1897 Gardner was inquiring about the *Madonna of the Candelabra*, which Berenson dismissed as containing nothing by the master himself save "the *idea of the composition*" (fig. 7). He jested, "the next thing we shall hear is that the Boston Museum of Fine Arts has bought it for $100,000. My acquaintance was asked £8,000. I think £800 a fairer price." Eventually purchased by Henry Walters in 1901, the painting is today displayed in his Baltimore museum (fig. 8).

In November the German dealer Charles Sedelmeyer offered her the Colonna altarpiece, a monumental Madonna and Child with saints that Raphael made for a convent in Perugia, one of the painter's earliest securely documented commissions (fig. 9). Yet Berenson delivered an even more scathing assessment than that of the *Madonna of the Candelabra*, noting that the Colonna

6. Titian Room showing *Christ Carrying the Cross* by the Circle of Giovanni Bellini, Isabella Stewart Gardner Museum, Boston

Hotel Caspar Badrutt
S. Moritz, Aug. 11 1897.

Dear Mrs. Gardner.

I know all
about the "Raphael."
It is the so-called
"Candelabra Madonna." &
the heirs of Col. Mon-
roe have been years
trying to sell it.
I know people who
have been approached.
Perhaps the National
Gallery would buy it.

7. Bernard Berenson, Letter to Isabella Stewart Gardner
from St. Moritz, Switzerland, 11 August 1897.
Isabella Stewart Gardner Museum, Boston

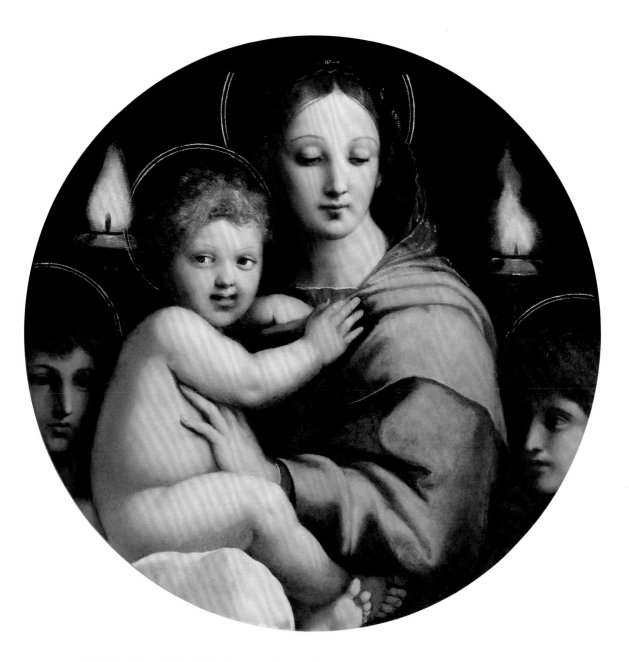

8. Raphael, *Madonna of the Candelabra*, about 1513. Oil on panel, 119.6 × 125.7 × 21 cm. The Walters Art Museum, Baltimore

9. Charles Sedelmeyer, *The Madonna of Saint Anthony of Padua, Also Known as the Great Colonna Madonna, Painted by Raphael Sanzio.* Library of the Museum of Fine Arts, Boston

figures' hands "run like pancakes before frying has given them consistency" (fig. 10). Following his advice, Gardner purchased neither, thanking him for saving her from that "tiresome dreary Colonna Raphael."

Today the Colonna altarpiece is recognized as an authentic Raphael and the *Candelabra* picture is acknowledged as a product of his studio, but in Gardner's time the two works shared the fact that they were both attributed to Raphael and the fact that they had been offered to her and by dealers other than Berenson. He jealously guarded relationships with the most important American collectors, and even though these were never exclusive arrangements, Berenson sought to dissuade clients like Gardner or John G. Johnson of Philadelphia from shopping elsewhere. In one famous episode, the connoisseur traveled to Philadelphia to see Johnson's new painting by Botticelli purchased through the British curator Roger Fry and English expatriate art historian Herbert P. Horne. When Berenson proclaimed that it could not possibly be the master's work but was instead that of an anonymous

studio assistant, whom he wittily dubbed "Amico di Sandro" (Sandro's Friend), Johnson exploded. The episode drove a wedge between Berenson and Horne that was not reconciled until the latter lay on his deathbed in Florence.

Gardner sourced works for her collection from many art agents, who mostly kept her young protégé at arm's length to prevent him from undermining their own opportunities for profit. In 1898 Gardner wrote to Berenson asking him to weigh in on the authenticity of a recently surfaced Raphael owned by the gallery Agnew's and offered by Richard Norton, the son of Harvard professor Charles Eliot Norton. Norton responded testily that "Berenson will not be allowed to see the picture for the simple reason that he is dishonest. . . . What makes Agnew angry with him is his going to men like Salting [an English collector] (a rather silly old man who buys fine things) & trying to persuade him that Agnew has cheated him." To add insult to injury, Berenson had also published several letters in a weekly journal condemning a fellow dealer.

Not one to miss an opportunity, Berenson began looking for Raphaels but found few that were available. In the meantime, he proposed to quench Gardner's thirst for the master with the closest he could get to the real thing. The attribution to Correggio of *Venus Wounded by a Rose Thorn* (fig. 11) was key to his sales pitch, for, as the scholar eloquently explained, "Raphael and Correggio were cousins, so to speak, and never approach so closely as here." In fact, no consensus exists over the unknown painter of this work, who is certainly not Raphael.

If Gardner was to acquire an authentic Raphael, then it would have to come from him. Several months after she had rejected the *Madonna of the Candelabra* and the Colonna altarpiece and had purchased a Raphaelesque "Correggio," Berenson was finally in a position to

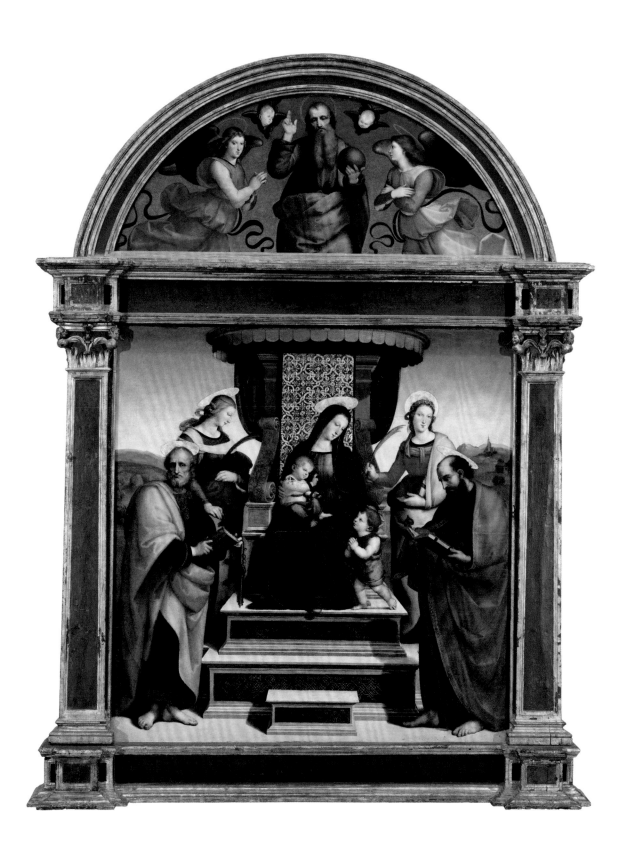

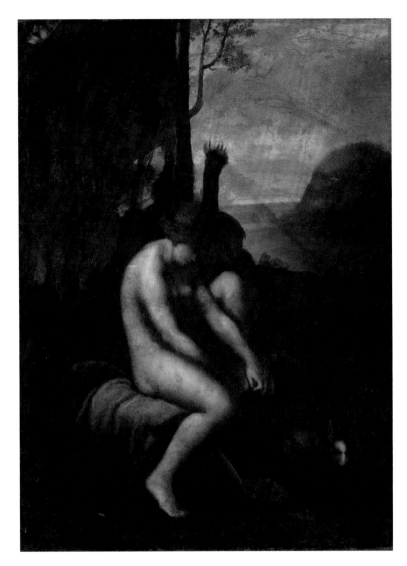

11. Italian, *Venus Wounded by a Rose Thorn*,
1500–1550. Oil on canvas, 97.7 × 71.8 cm.
Isabella Stewart Gardner Museum, Boston

offer one himself. He delivered the opening pitch on 16 January 1898 (fig. 12): "I have for you a consolation of the most extraordinary and unexpected kind. Let me say at once, I propose to you a portrait by—Raphael." The name must have rung like a gong in her head. Yet when she saw the enclosed photograph, her enthusiasm may have been more muted. He offered a painting of a corpulent, walleyed cleric (see fig. 24). The portrait of Tommaso

Inghirami hardly fulfilled her dream of owning one of the painter's ravishing Madonnas, but Berenson preempted her concern, noting that Raphael's portraits were even rarer, and its price, £15,000, represented a fraction of the cost of a Virgin and Child. He concluded by emphasizing the unique nature of the opportunity, pointing out that the portrait had only just become available and exclusively through him.

As was often the case, Berenson's claim was loaded with hyperbole. First, the Inghirami family had given the option to sell the picture to the Florentine art dealer and antiquarian Emilio Costantini, a frequent Berenson partner who had recently fallen out with Gardner through perceived mistreatment on a previous transaction and whose identity Berenson had concealed to placate his patron. Second, the portrait had in fact been on the market before. Nearly a decade earlier, in 1890, the English art dealer and agent Charles Fairfax Murray had suggested it to Wilhelm von Bode for the Berlin Museum. That transaction never came to pass, and it remains unclear how the painting ended up with Costantini.

Back in Boston, Isabella deliberated over the price and the money she had already spent on other recent purchases. Her husband, John L. Gardner, Jr., still played a key role in the family finances, and Gardner replied to Berenson that she could hardly buy without his consent. She claimed that such approval was impossible, as he was traveling in the American West, but it is also possible that this was part of her bargaining strategy to reduce the price. Disaster suddenly interrupted the delicate negotiation in mid-February, when Gardner tripped on her way down the stairs at 152 Beacon Street, broke her leg, and was laid up in bed for several weeks while it healed (figs. 13 and 14). Henry James hoped that extra time spent with Titian's *Europa* could console her: "My imagination shoved rose leaves, as it were, under the spine of a lady for whom lying fractured was but an occasion the more to foregather with Titian. Seriously, I hope you weren't very bad—that it was nothing more than the 'Europa' could bandage up with a piece of purple."

Newspapers reported almost gleefully on Isabella's incapacitation and its impact on her social calendar (fig. 14). Despite Isabella's courageous excursions

in a wheelchair—including to the opera (Wagner's *Lohengrin*), perhaps in part to prove them wrong—housebound convalescing drove her to distraction. With the snow swirling through the streets of Beacon Hill and Jack Gardner away, Isabella despaired of her confinement and the drastic curtailment of the season's social life, resigning herself to writing letters in pencil because "flat on my back, ink does not do!"

As Berenson continued his attempts at persuasion, Isabella put him off yet again. He warned her that this opportunity "occurs but once in a generation, and that to let it slip would be making *il gran rifiuto*. I should be sorry in the first place for both of us, and then for America." The young connoisseur was well aware that she was already planning for her future museum. Hoping to fill both Gardners with confidence, he described making a special visit to the Palazzo Inghirami in Volterra to examine the picture, reassuring them of its superior quality (fig. 15). Yet, when Jack finally returned to Boston at the end of February, he took an immediate dislike not only to the picture but also to its price. Gardner responded that her husband forbade its purchase but refused to give up "without a kick (even with my plaster leg). So tell me again if I must have it, and what is the *lowest* price."

Berenson likely dismissed her predicament as shrewd negotiating, as she often claimed poverty in attempts to lower the price of works offered. However, Gardner had spent a record sum on art in 1897 ($253,388) and was on track to beat it in 1898 ($381,700) with nine of the most expensive paintings sourced through Berenson himself. Whatever the actual state of her

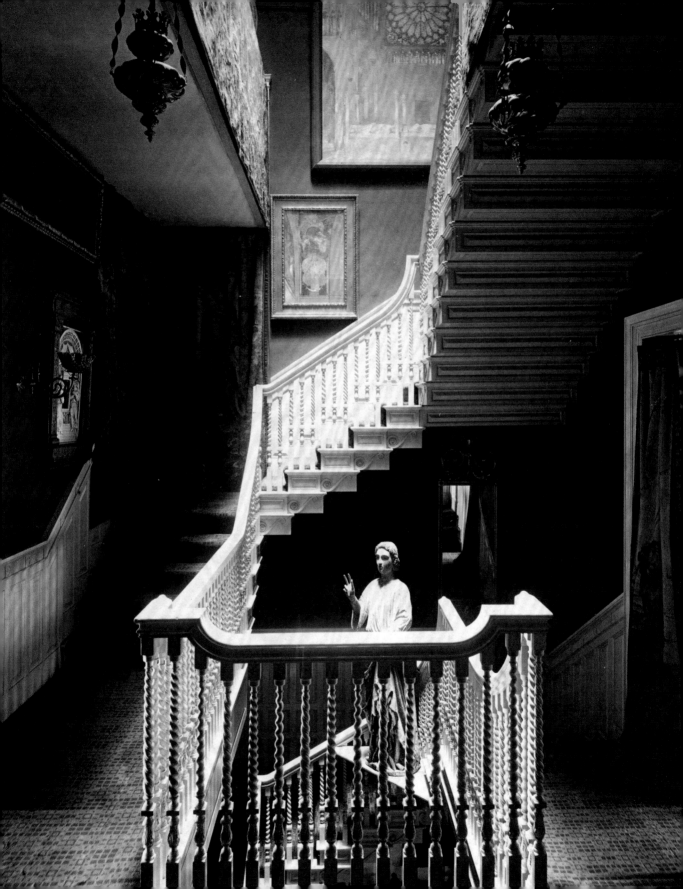

MRS. "JACK" GARDNER HURT.

Boston's Society Leader Laid Up in Bed with a Broken Leg.

BOSTON, Feb. 13.—Mrs. "Jack" Gardner, the society leader, has broken one of her legs. It is said the break is a severe one. Just how the misfortune happened is not known.

All the social functions of the season in which Mrs. Gardner was interested as promoter have been declared off. At present Mrs. Gardner receives only close friends at her bedside.

Notwithstanding her affliction, Mrs. Gardner will attend the Pugno concert at Music Hall next Friday afternoon. She will be lifted from her carriage at the door of the hall, and, after being deposited in a rolling invalid chair, will be wheeled across the floor to her seat.

finances, the Inghirami situation changed dramatically when Costantini, the art dealer in whose possession the picture remained, wrote to Isabella directly and offered her the painting for £8,000, nearly half the £15,000 asked by Berenson. With his own profit suddenly revealed and his negotiating position undermined by his presumed partner, Berenson did the only thing he could to preserve his reputation and any future relationship with Gardner. He conceded the sale for £7,000 ($36,455), an even more deeply discounted price. On 13 March he wrote, "The Inghirami is yours, one of Raphael's very greatest works, and for a price that must be considered the greatest bargain of the century. Pictures have gone up in value from twelve to twenty times in the last eighty years. But even in the beginning of this century Inghirami would have fetched at least as much as you are paying for it now."

Success aside, this encounter fueled the Gardners' suspicions that their preferred adviser was not acting with the couple's best interests in mind. Both demanded an explanation for Berenson's sudden discount. His feeble story—that he had always hoped to get it on the cheap, that he had fortuitously received confidential information that the Inghirami family had been refused a bank loan for 200,000 lire (about £7,000), and that he had put this information to use as a bargaining chip—was just as difficult to believe then as it is today. Jack Gardner remained skeptical, a suspicion that only deepened when, later that spring, Berenson offered Isabella a portrait by Dürer, and she replied that friends in Paris had just proposed it to her for less. She wrote, "*They* say (there seem to be many) that you have been dishonest in your money dealings with people who have bought pictures. Hearing this Mr. G. instantly makes remarks about the Inghirami Raphael you got for me."

Yet she was as quick to forgive as he was to excuse, even if this was hardly Berenson's last exposed charade.

Later in the autumn of 1898, Gardner purchased through him a pair of portraits by Holbein from a private English collection, subsequently threatening legal action after receiving from the family who sold them a letter detailing Berenson's markup. Such dramas of his own making drove the dealer to despair, but even the most outrageous incidents of overcharging never opened a permanent rift between them. Instead, her steady stream of purchases for Boston helped to fill his new residence in Florence with the same kinds of Italian paintings that he sought to sell abroad. And luckily for Berenson, when Jack Gardner passed away suddenly in December 1898, he took his own suspicions about the connoisseur's profit margins to the grave.

Gardner celebrated her triumph but anxiously awaited the arrival of the portrait on American shores. The acquisition of the first Raphael in America unfolded against the backdrop of far more consequential events on the world stage. Following the explosion of the USS *Maine* in Havana, the United States was at war with Spain, and the blockades threatened any ship sailing under an American flag. Tribulations over the Inghirami sale were matched by the uncertainty surrounding its export from Italy and shipment to Boston, as Berenson expressed to Gardner on Easter Sunday: "I am in a blue funk about the war we seem plunging into—chiefly on account of the Raphael. I shall

15. Palazzo Inghirami, Volterra

do my best to put it in a safe ship, possibly English."

In the meantime, the Inghirami sale was the talk of the art world in Florence, and Berenson eased her anxiety with uplifting gossip. He wrote, "Yesterday I had occasion to see Bardini [the Florentine art dealer Stefano Bardini], and he spent an hour raging up and down in fury over the sale of the Raphael. Of course he had no idea what part I had in it. He stalked up and down ejaculating, 'un Raffaello verissimo per un prezzo vile, dico vile, vile'" (the most authentic Raphael for a low price, low, I say). Berenson may well have embellished his meeting with Bardini, but the same tale that conveniently praised the art dealer's cleverness in the eyes of his local competition also sought to reassure Gardner of the remarkable deal she had managed to strike.

The painting's arrival on American shores in November 1898 filled Isabella with as much trepidation as had its departure from Italy. Instead of being able to hold an immediate welcoming reception for the portrait at 152 Beacon Street, Isabella had to wait while the customs authorities held up the painting and several

others in their warehouse. Itching with anticipation, Gardner headed for the docks and persuaded the commanding officer to grant her a clandestine visit. "A very dear old person at head of our Customs took me surreptitiously to the ware rooms and let me have a peep, only a peep though, at the Pesellinos the Inghirami, and the Bronzino. And I was in the 7th Heaven of delight." The thrill of her first Raphael did not disappoint.

Gardner's enthusiasm aside, Raphael's debut in America received only a modest public reception. A simple photograph and headline (fig. 16) celebrated the painting and its owner. One year later Gardner featured it in a charity exhibition of her growing collection. But neither event garnered the kind of attention that might have been expected of a purchase as momentous as this one. Several potential explanations come to mind. First, its arrival was overshadowed by the death of Jack Gardner and subsequent plans for the museum. Second, both Gardner and her admirers recognized that this portrait of a corpulent, walleyed cleric hardly

fit the profile of paintings by Raphael that American enthusiasts had come to expect.

Gardner felt the same way and continued to hunt for "A No. 1 Raphael *Madonna*," despite Berenson's assurance that the quest was "as good as hopeless." In the meantime, in 1900 she managed to acquire a jewel-like *Lamentation* (fig. 17), a fragment of the Colonna altarpiece she had been dissuaded from buying two years earlier, and which J. P. Morgan finally acquired in 1901. Berenson tried to placate her, "So if possible try to rest contented with the two Raphaels you have already, and turn your attention to something no less great if not greater." Gardner nevertheless continued to search, eventually settling for one more, a preparatory drawing depicting the Procession of Pope Sylvester I (fig. 18) for Raphael's (now lost) frescoes in the Vatican Palace.

Even if the portrait itself hardly attracted a resounding reception, its presence in her collection inadvertently fueled gossip over the shape of Gardner's new museum. As her palace began to rise from the Fenway marshes, speculation flooded newspapers up and down the East Coast. In 1899 the *New York Journal and Advertiser* featured a full-page spread with the headline "Mrs. 'Jack' Gardner Has Bought an Italian Palace and Will Ship It to Boston and Set It Up There as an Art Memorial to Her Husband." Isabella harbored no such intention, but the article reported from anonymous sources who claimed that she had already purchased a Florentine palazzo, comparing this unknown building to the largest in Florence, the Palazzo Pitti (fig. 19). Not coincidentally, the Pitti was and is a museum and home to another portrait of Inghirami by Raphael, the version that Berenson and other contemporaries considered a copy or alternative to the Boston original. This rumor took on a surprising new dimension when the *Philadelphia Inquirer* announced, "The palace as it will look when completed," publishing photographs of the

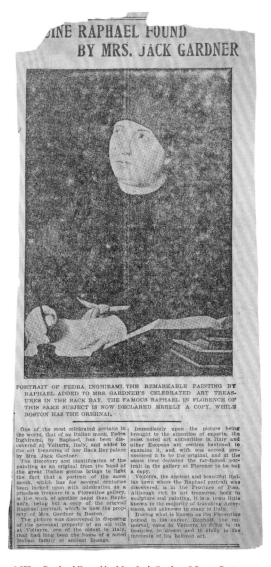

16. "Fine Raphael Found by Mrs. Jack Gardner," *Boston Post*, about 1898. Isabella Stewart Gardner Museum, Boston

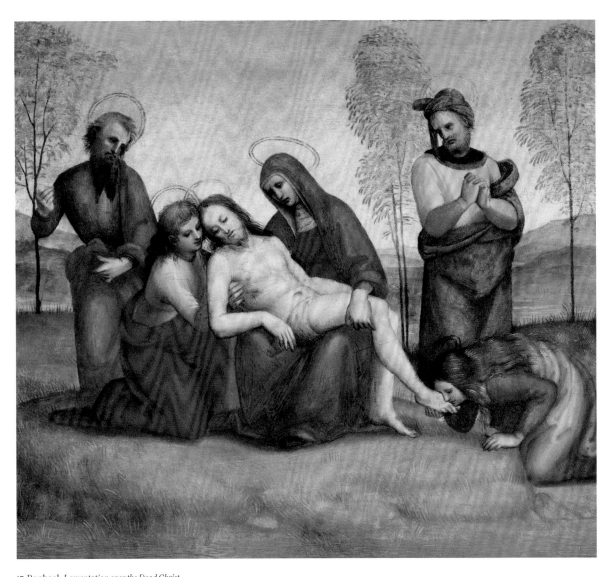

17. Raphael, *Lamentation over the Dead Christ*,
about 1503–5. Oil on panel, 23.6 × 28.8 cm.
Isabella Stewart Gardner Museum, Boston

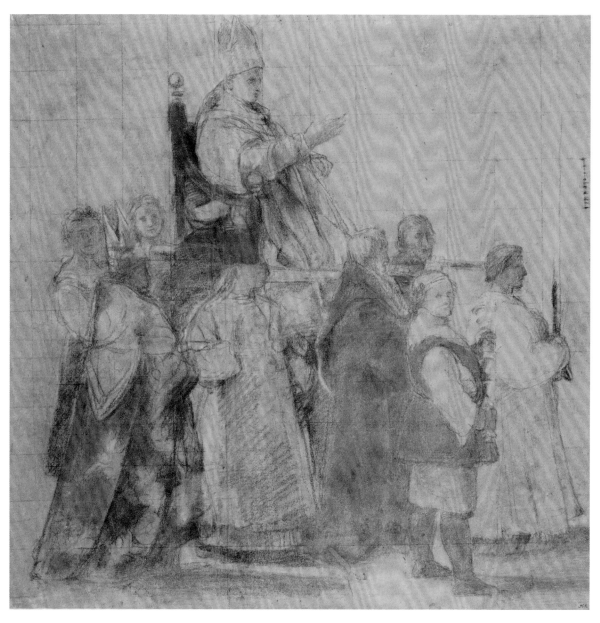

18. Raphael, *Procession of Pope Sylvester I*, about 1516–17.
Colored chalks on paper, 39.8 × 40.3 cm.
Isabella Stewart Gardner Museum, Boston

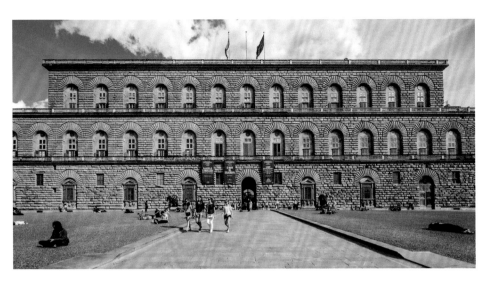

19. Palazzo Pitti, Florence

Palazzo Pitti and Gardner's *Tommaso Inghirami* (fig. 20). Such flights of fancy were quickly put to rest when Fenway Court was completed in 1901 but the newspaper story remains as a dramatic tribute to one of Gardner's most colorful acquisitions.

Despite any hesitations over the painting's beauty, Gardner named an entire gallery of her new museum after the Renaissance master. She covered the Raphael Room's walls in brilliant red fabrics inspired by Inghirami's alb and featured his portrait prominently on a wall facing visitors when they entered the space. The first Raphael in America joined this country's debut Botticelli and Carlo Crivelli (fig. 21). Aligned like trophies, the three works in this arrangement celebrated Gardner's triumph in her mission to bring the best of European art to this country. Over the years, she shifted many of the works in Fenway Court's inaugural installation, but the Inghirami remained firmly anchored in its original place, and she featured a short biography of him in her 1917 handwritten catalogue of paintings. To this day it remains one of the most fascinating works in the collection and a testament to the founder's remarkable achievements.

BIBLIOGRAPHIC NOTE

This text relies primarily on the correspondence between Isabella Stewart Gardner and Bernard Berenson, first published by Rollin N. van Hadley in 1987. The episode involving Wilhelm von Bode comes from the Charles Fairfax Murray letters published by Paul Tucker in 2017. I would like to thank Ilaria Della Monica for finding an unpublished letter in the I Tatti archives in which Gardner describes the Colonna altarpiece as "dreary." Carl Brandon Strehlke's essay in the catalogue of Italian paintings at Villa I Tatti helped to set the scene in Florence as Berenson moved into La Canovaia. The most comprehensive assessment of Gardner's taste for Raphael can be found in "Raphael's Prestige" by David Alan Brown in the catalogue of his 1983 exhibition *Raphael in America*.

Brown, David Alan. "Raphael's Prestige." In *Raphael in America*, 15–108. Exh. cat. Washington, DC, 1983.

Strehlke, Carl Brandon. "Bernard and Mary Collect: Pictures Come to I Tatti." In *The Bernard and Mary Berenson Collection of European Paintings at I Tatti*, edited by Strehlke and Machtelt Brüggen Israëls, 19–46. Florence, 2015.

"A Connoisseur and His Clients: The Correspondence of Charles Fairfax Murray with Frederic Burton, Wilhelm Bode and Julius Meyer (1867–1914)." *Walpole Society* 79, edited by Paul Tucker. Oxford, 2017.

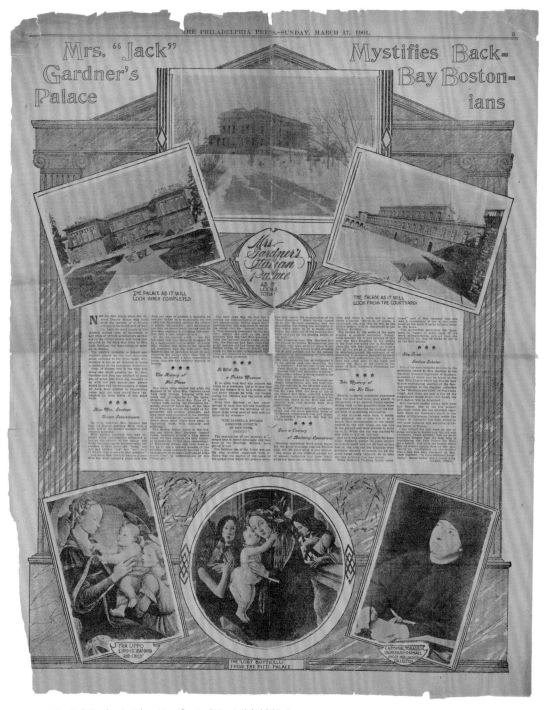

20. "Mrs. Jack Gardner's Palace Mystifies Back Bay," *Philadelphia Press*,
17 March 1901. Isabella Stewart Gardner Museum, Boston

OVERLEAF

21. Raphael Room, Isabella Stewart Gardner Museum, Boston

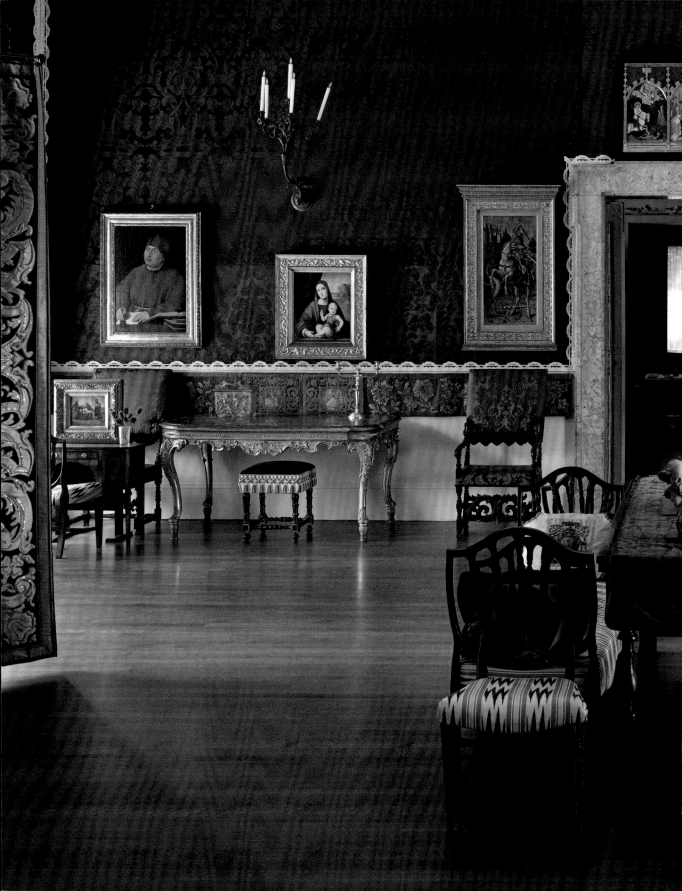

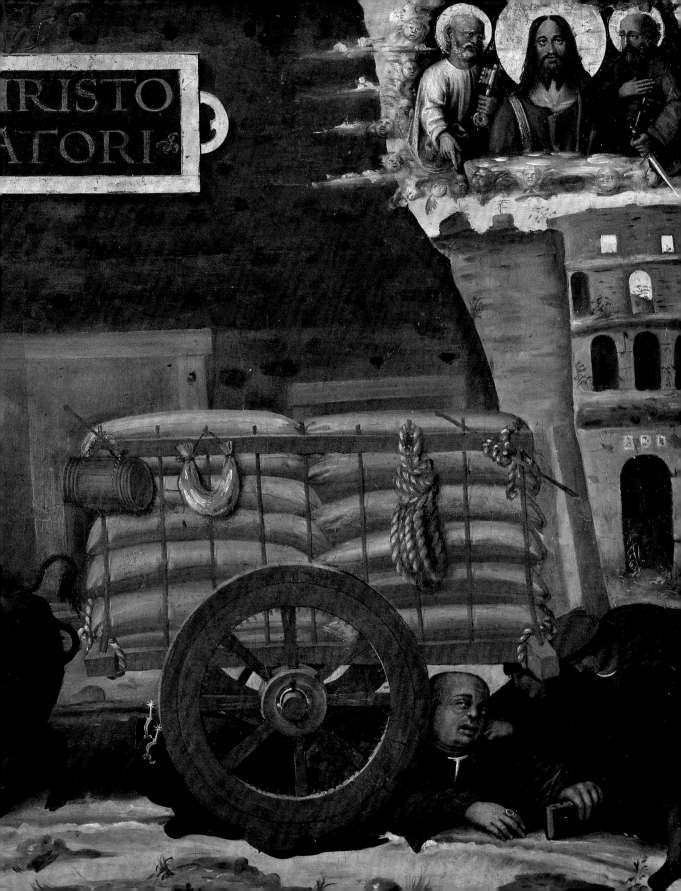

Tommaso "Fedra" Inghirami

INGRID ROWLAND

In his own day, the early sixteenth century, Tommaso Inghirami was a celebrity (fig. 24). As Erasmus said of the friend he first met in 1509, "a great part of happiness is being a celebrity in Rome," and Inghirami's star power rested on the eloquence that led Erasmus to call him "the Cicero of our era." Another luminary of the age, the poet Ludovico Ariosto, placed Inghirami amid the contemporary literary pantheon in the final canto of his hilarious best-selling epic *Orlando furioso*. When the great orator died in Rome at the age of forty-six, his longtime friend Raffaele Maffei remembered him with a more double-edged compliment. On the one hand, Maffei remarked, Tommaso was "a man gifted by nature with a greater number of talents than anyone I have ever seen or heard of in our time," whose "wit was, in a certain sense, on tap, so that whatever he undertook succeeded magnificently." But then Maffei unleashed his barb: "And if only he'd applied those heavenly gifts for the various arts to the things that make for true glory and happiness, no one would have been more blessed than he."[1] Maffei was a crusty old friar in his mid-sixties, and the letter in which this description appears is addressed to his younger brother Mario, Inghirami's best friend in all the world. His little lecture about Tommaso's wasted talents is clearly meant to take in Mario as well, for "the twins" (as Maffei's mother called them) were two of the most flamboyant characters in the glittering pageant of Renaissance Rome.

In 1516, when Maffei wrote his commemoration, Rome seemed to have attracted a miraculous number of people with extraordinary "heavenly gifts." The resident artists included Raphael and Leonardo da Vinci. Michelangelo had only recently departed the Eternal City for Florence. Maffei may well have been thinking of more aristocratic professions, such as statesmen, or scholars like himself. Both he and Inghirami had known, among many others, Lorenzo de' Medici, Machiavelli, Erasmus, and Pope Julius II, not to mention a host of the other extraordinary figures who had transformed Rome into a cultural center to rival Florence and Venice, including the composer Josquin Desprez, the architect Donato Bramante, the popular musician Serafino Aquilano, the Venetian writer Pietro Bembo. If Tommaso Inghirami ranked alongside talents of this magnitude, it was no wonder that he decided to commission a portrait by Raphael, just like the cardinals, popes, and wealthy bankers who dominated Roman society. Unlike Maffei, moreover, Raphael would have looked on Inghirami with the admiring eyes of a young, ambitious courtier in his mid-twenties; his rich and famous sitter was one of the city's most scintillating, important personalities. What emerges from Raphael's completed work, however, is the painter's sense that Inghirami is, in a profound way, a fellow artist. The sensitive portrait suggests that perhaps Tommaso's divine talents may not have been so misdirected after all.

Tommaso Inghirami was born in 1470 in Volterra, an ancient walled city on the western seaboard of Tuscany, prosperous thanks to its minerals, salt, and fertile soil, but remote from bustling centers like Pisa, Florence, and Siena. Volterra was founded by the Etruscans, and to this day, the weathered busts of two-thousand-year-old Etruscan gods still glower down from one of its city gates. The Inghirami family, however, were relative newcomers, who traced their Germanic name (Ingram) back to one of the knights who went to Volterra in 967 with Holy Roman Emperor Otto I and never left. Along with the resources that

23. Palazzo Inghirami, Volterra

24. Raphael, *Tommaso Inghirami*, about 1510. Oil on panel, 90 × 62.5 cm. Isabella Stewart Gardner Museum, Boston

had attracted Otto in the tenth century, the discovery of another mineral resource attracted the attention of Lorenzo de' Medici (Il Magnifico) in the fifteenth: alum, an essential and rare ingredient used in dyeing cloth.

Tommaso's father, Paolo "Pecorino" Inghirami, had been dealing in alum as one of Il Magnifico's agents in Volterra when he was killed by a mob and dragged through the streets in February 1472; not everyone in Volterra was happy with increased Florentine interference in local affairs. But Florence provided a safe home for the rest of Inghirami's family as their properties in and around Volterra were confiscated by the city council. Four months after Paolo Pecorino's murder, in June 1472, Il Magnifico subjected Volterra to a sack so brutal that the city has never forgiven him.[2] Lorenzo sealed his conquest by building an enormous fortress at the highest pinnacle of Volterra, a bristling bastion designed to repel the latest in gunpowder artillery, so impregnable that today it serves as a medium-security prison.[3] The Inghirami, along with

the other members of the pro-Florentine faction, eventually regained their property in Volterra, but Tommaso's immediate family stayed on in Florence under Lorenzo's watchful eye. No doubt preceded by a more modest structure, the present-day Palazzo Inghirami, like the Inghirami Chapel in Volterra Cathedral, was commissioned in the early seventeenth century by another illustrious Inghirami, Admiral Jacopo (fig. 23).

As the second son in an aristocratic Italian family, Tommaso was destined by tradition for the Church, just as his elder brother Nello was expected to marry and produce the family's heirs. To further this choice of career, again with Lorenzo's encouragement, in 1483 the adolescent Inghirami moved to Rome, where he found a close coterie of mentors, including two uncles, all of them with excellent connections within the complex patronage of the Vatican. In those days, the pope was a temporal monarch as well as a spiritual leader, with responsibility for ruling much of central Italy. As a result, the Curia, the governing structure of the Papal State, employed people in a vast range of positions, including finance, diplomacy, industry, and service as well as religion. For many of these curial posts, priestly vows were unnecessary, and Inghirami himself was never ordained (which may be one of the reasons that Raffaele Maffei, a priest in the Servite order, suggested that his friend had missed out on the true rewards of life). For living quarters, young Tommaso was absorbed into the vast household of Raffaele Riario, cardinal of San Giorgio, nephew of the recently deceased Pope Sixtus IV. It was a perfect setting for a destitute exile to learn about the workings of Roman society, and Inghirami did; he became a shrewd investor and quickly amassed a fortune in real estate.

As a first step toward his church career, however, Tommaso enrolled in the University of Rome's

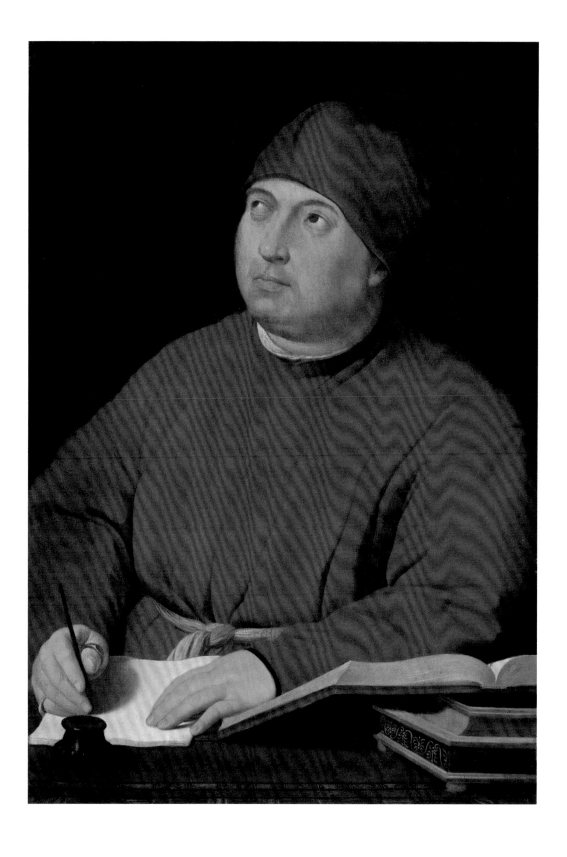

25. Maria Magdalena Andrzejkowicz-Buttowt, *Cardinal Giovanni Medici and Pomponius Laetus at the Roman Excavations*, 1878. Oil on canvas, 173 × 128 cm. National Museum, Warsaw

26. Catacombs of Saints Marcellino and Peter, 4th century
with 16th-century graffiti by Julius Pomponius Laetus

revolutionary new program of humanistic studies, headed by the brilliant, eccentric scholar whose adopted Latin name, Julius Pomponius Laetus, is the only one we know.[4] Laetus taught his students about ancient Rome by full immersion. He and his pupils conversed in Latin and wandered the ruins wearing togas, all the while they were laying the foundations of modern systematic classical studies (fig. 25). They compared different manuscripts of ancient texts with one another, and then compared the testimony of ancient writers with the monuments they saw all around them. Inghirami's classmates included an energetic young Roman aristocrat (and future pope) named Alessandro Farnese, whose skills in Greek and Latin were nearly as brilliant as his own. They quickly forged a lifelong friendship.

We can reconstruct something of the life Laetus and his students led from the manuscripts they have left behind, filled with notes about life, literature, and the eternally fascinating city. They scrawled graffiti (fig. 26) just like modern tourists on ruins ranging from the catacombs to the buried vaults of Emperor Nero's legendary Golden House (which they mistook for the baths constructed by his successor Titus).

They celebrated Rome's birthday on 21 April, with a nod to the Christian saints who shared the same feast day, Victor, Fortunatus, and Genesius.[5] When they spoke and wrote Latin, they tried their best to use only words that had been current in the time of Cicero and Julius Caesar, or, at the latest, Virgil, Horace, and the emperor Augustus, avoiding the pompous inventions of Rome's medieval bureaucracy. It meant running into difficulties with finding a word for many aspects of Christian life, from nuns ("Vestal Virgins") to pizza ("pita") to the pope himself ("Jupiter the Thunderer"), but ancient Latin also had a clarity and an emotional power that made for compelling sermons. These

avant-garde scholars were cleaner than most of their contemporaries because, like ancient Romans, they enjoyed taking baths. Strikingly, the most prosperous residences in early modern Rome, the ones that belonged to cardinals and bankers, were outfitted with hot and cold running water. Despite continuing suspicions about their motives, Pomponius and his students were not out-and-out pagans; they were no more interested in giving up their Christian salvation than they were in renouncing medieval amenities like paper, gunpowder, and the magnetic compass. They simply wanted a modern world, and a modern religion, that endowed new ideas with the elegance, beauty, and refinement of classical antiquity.

In 1486 the students at the University of Rome and their professor of grammar, Sulpizio da Veroli, decided to take their full immersion course to a new level, by staging an ancient Latin tragedy for the first time since late antiquity. Cardinal Riario, Tommaso Inghirami's sponsor, agreed to help with the expenses. They chose a play by Seneca, the Stoic philosopher and ill-fated tutor of the emperor Nero, knowing that the moments of high drama—and with Seneca there is always high drama—came with a reliably strong moral message. Still, the story of Queen Phaedra of Athens and her overwhelming, illicit passion for her stepson Hippolytus was a provocative choice for performing in a cardinal's palace, even a cardinal as worldly, and as mad for theater, as Riario. At least Phaedra and Hippolytus die for their sins in the course of the drama, Phaedra in suicidal despair at a lust that combined incest with adultery, Hippolytus trampled by heavenly horses for spurning love altogether, and for doing so with such bad manners. Tommaso Inghirami, already a rising star among his classmates, took the role of the lovesick queen.

Under Sulpizio's learned guidance, the students created a classical stage set (fig. 27), following the

27. Raphael, *Perspective Study for a Theater Scene*, 1518–19. Pen and brown ink over graphite, 61.8 × 28.7 cm. Gabinetto dei Disegni e delle Stampe delle Gallerie degli Uffizi, Florence

28. Cardinal Riario's Palace, the Palazzo Cancelleria, Rome

description supplied by the ancient architect Vitruvius in the fifth of his *Ten Books on Architecture*, a text that Sulpizio was editing at that very moment and would publish later the same year. The play made its debut in the public square known as Campo de' Fiori, a vast open space used as a market and an execution ground, and it was here, during one of Queen Phaedra's soliloquies, that the stage set suddenly collapsed around the young actor. Inghirami turned the potential disaster into triumph by improvising magnificently in Latin verse until his colleagues could haul the fallen set back into place. Or at least so we hear from another illustrious Inghirami, Curzio, a brilliant dramatist who is far better known for the forged "Etruscan Antiquities" he began to unearth in 1634.[6] Beyond any doubt, however, for Erasmus tells us so, a star was born on the spot. By the time the students repeated their performance in the Riario palace, Palazzo Cancelleria, (fig. 28), Tommaso Inghirami had become the most famous actor in Renaissance Rome, and he had earned himself a nickname, "Phaedra." Perhaps his performance

is one of the reasons that the play itself, which his contemporaries called *Hippolytus*, is known today as *Phaedra* (the manuscripts that preserve the text refer to it by both names).

Inghirami himself was not entirely happy with his new feminine nickname. He tried for the rest of his life to convince people to use the masculine version, Phaedrus, the name of a handsome Athenian youth who appears in several of Plato's dialogues, including the one named after him. Many of Tommaso's closest friends, like the Maffei brothers, obliged him by calling him "Phaedrus" or "Fedro." But to the public, and to his own family, he would always be "Fedra."[7]

From this moment onward, moreover, Inghirami's contemporaries, from Raffaele Maffei to the famous preacher Giles of Viterbo, would agree without exception that his most remarkable quality was his voice, with its resonance, volume, and the clarity of his diction. He belonged to a generation that was beginning to shift its communication from manuscripts to printed books, but for Tommaso Inghirami this transition was

not such a crucial one, since his own chosen medium was and would remain performance. His greatest achievements, then, were all experiences of a moment. And they were precisely the kinds of sensation that Raphael could not convey in the mute medium of paint.

The most devoted university students could take their full immersion in the ancient world still further by joining the classical club that Pomponius Laetus had created, the Roman Academy. Meeting for the most part in his garden, members took Latin names, wrote Latin poems, and delivered speeches in Latin. Laetus held the office of "Pontifex Maximus"; Tommaso Inghirami eventually became "Master of the Cavalry" (Magister Equitum), the title of an ancient Roman magistrate who served as lieutenant to a dictator—in short, he served as the academy's vice president, thanks to his merits as Pomponius's most brilliant student. The institution's early years had been troubled. In 1467, before Inghirami's birth, a suspicious Pope Paul II had thrown most of the Roman Academy's members, including Laetus, into prison on charges of paganism, republicanism, and sodomy, subjecting many of them to torture before they were put on trial and finally acquitted. Officially, like Plato's Academy, the Roman Academy was registered as a religious sodality, but it continued to keep a discreet profile in later years. We therefore know that it existed but have little detailed knowledge about what its members actually did. We do know that Inghirami found a shelter for his own sexuality in ancient authors who shared his preference for the company of handsome young men. Machiavelli's secretary Agostino Vespucci wrote from Rome that "if they hadn't found protection with this and that cardinal, they would long since have been burned at the stake."[8]

In 1493 Inghirami took his first step toward a career in the Church, an appointment as deacon to the papal chapel of Alexander VI Borgia, a Catalan who had spent several decades running the Vatican's finances and reigned as pope from 1492 to 1503. Tommaso's combination of impeccable Latin and skill at public speaking made him an increasingly valuable asset to the papal diplomatic corps in a swiftly deteriorating political situation. From 1494 onward, Italy, its hilly terrain partitioned among a series of small city-states, became a bloody ground of contention between two large European monarchies, Spain and France.

Inghirami, an accomplished poet as well as an orator, became a refined instrument of papal policy, shaping public opinion by dispensing praise and blame in public orations, prose, or verse as the occasion demanded. When the French king Charles VIII invaded Italy in 1494, Inghirami wrote two long poems urging Romans to restore their ruined city to its ancient glory—in other words, to wake up. In 1495 he commemorated the great Dominican saint Thomas Aquinas in the Dominican church of Santa Maria sopra Minerva. For a religious order that specialized in learned eloquence— the Dominicans are officially known as the Order of Preachers—this tribute to the oratory of a non- Dominican was a high honor indeed. In the summer of 1496 Inghirami went abroad on his first diplomatic mission, one of fourteen scriptors or secretaries assigned to the entourage of Cardinal Bernardino Carvajal, the Spanish ambassador to the Holy See, as he traveled to Innsbruck to meet Holy Roman Emperor Maximilian I on the pope's behalf. The expedition to Austria lasted for months, with a protracted stay in Milan that frustrated Inghirami but also allowed him to spend time exploring the city's libraries. The connection with the cultured, worldly-wise Carvajal did him no harm either.

Inghirami returned to Rome amid steadily increasing assignments as an orator. In his lifetime, he would be called on to pronounce funeral eulogies for a succession of princes and cardinals, and eventually a

29. Maarten van Heemskerck, *Northern Transept Facade of Saint John Lateran*, about 1532–36. Pen and brown ink and wash, 13.6 × 21 cm. Staatliche Museen zu Berlin

pope. His activities as an actor and theatrical director continued as well. With the death of his mentor Pomponius Laetus in 1498, he began teaching at the University of Rome, and in that capacity traveled to Naples with a troupe of student actors in 1501 to perform for the king. In January 1503 Pope Alexander appointed Inghirami a canon of Saint John Lateran, which gave him responsibility for running the day-to-day operations of the great basilica, the first church to be officially consecrated in Rome, by none other than Constantine himself, in 318 (fig. 29). The Lateran was, and is, the mother church of Roman Catholicism. Saint Peter's was consecrated in 324, and a fierce rivalry between the two basilicas has raged ever since.

Six months later, the pope was dead. As a canon of the Lateran, Inghirami took part in the conclave that appointed Alexander's successor in October 1503, a sickly Sienese, Pius III, who died after twenty-six days, too ill to attend his own coronation. When the cardinals reconvened for the second conclave of 1503, again with Inghirami in attendance, they knew who would emerge victorious: Giuliano della Rovere, Cardinal Riario's ferocious cousin. The election of Pius III had been an attempt to stave off the inevitable, in hopes that the cardinals could catch their collective breath, but in December 1503 they cast their votes for the man who would guide the Vatican through ten of the most brilliant and tumultous years of its millennial history, and transform the lives of Raphael and Tommaso Inghirami: the former Cardinal Giuliano, Pope Julius II (fig. 30).

Ruthless and fiercely intelligent, Julius, a Franciscan priest, burned with ambitions for the

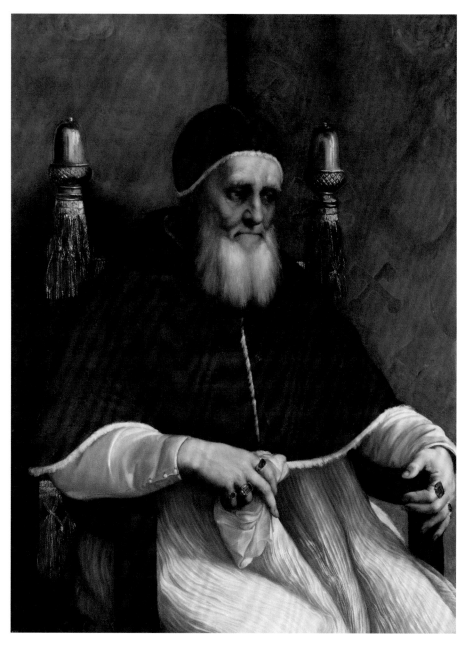

30. Raphael, *Pope Julius II*, 1511. Oil on poplar panel,
108.7 × 81 cm. The National Gallery, London

31. Tommaso Inghirami, List of Greek books to be bound, 1501–25. Vatican Library

32. Binding of Greek book commissioned by Inghirami, Vatican Library

place of the Church in the modern world and used every medium at his disposal—art, architecture, city planning, oratory, money, and troops—to carry his version of the Christian message to the far ends of the globe. We know him best today for his willingness to charge into the battlefield in full armor and for his patronage of art, for the penetrating vision that led him to force Michelangelo, a sculptor, to fresco the ceiling of the Sistine Chapel, and fire the whole team of artists assigned to decorate his private apartments once he saw what a young man named Raphael could do. Rough and ready in his manners, Julius never claimed to be a scholar, but from the moment he was appointed cardinal in 1471 he took an intense interest in the Vatican Library and endowed several Franciscan libraries in Rome over the course of his career. Over a span of thirty years, his portraits, by

artists as diverse as Botticelli, Melozzo da Forlì, and Raphael, show him in one of two positions: striding forward with a look of sheer aggression on his handsome face; or with his head bowed, utterly lost in thought. Like a number of his contemporaries, he was both a frenetically active participant in the world around him and a true intellectual.

In Tommaso Inghirami, for all their differences of age and background, Julius found a kindred soul. He appointed Tommaso *praepositum*—effective head—of the Vatican Library (fig. 33) in 1505, as well as the caretaker of his own private collection of three hundred books (an immense number for that era). Five years later Inghirami officially assumed the role of prefect, the library's highest office, with responsibility for lending policy, accounts, archives, and the physical care of more than 3,500 manuscripts as well as a growing

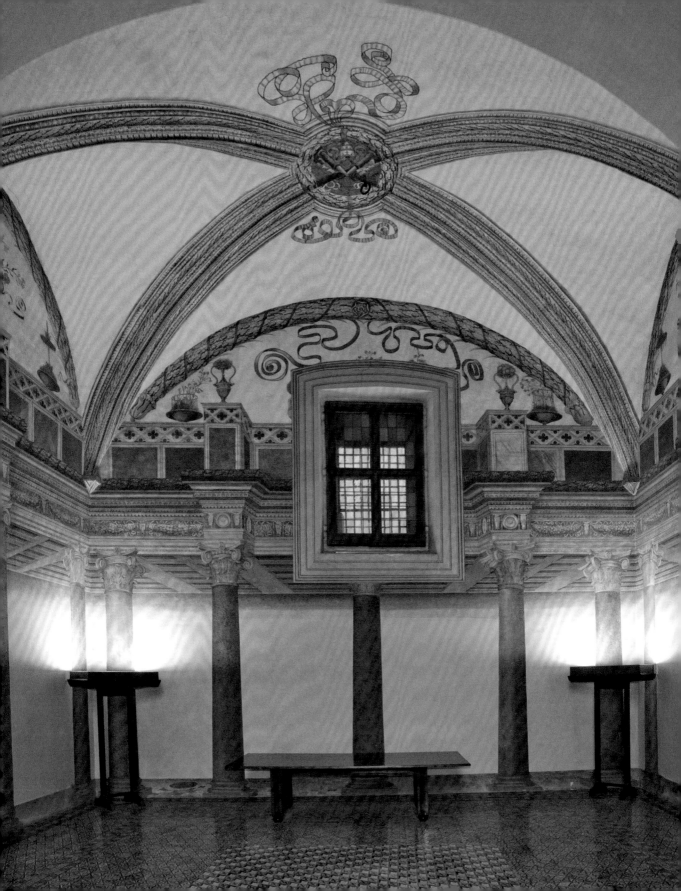

33. Bibliotheca Graeca, one of the Vatican Library rooms
where Inghriami worked, built by Pope Sixtus IV
in the 15th century

collection of printed books in Latin, Greek, and modern vernacular, all of them lovingly preserved in fine, custom ordered leather bindings (figs. 31 and 32).

Despite such professional success, danger was often just around the corner. In 1508, as he rode out from his garden house on the Palatine Hill, Inghirami crashed into an ox-drawn grain cart that knocked him from his mule and rolled over him just beneath the Arch of Titus in the ruins of the Roman Forum (fig. 34). In gratitude for his survival, he ordered a large votive plaque that he offered to Christ the Savior, the prime patron of the Lateran basilica. Votive panels were, and are, more folk art than refined masterpieces. The artist who carried out Inghirami's order was either a craftsman who was nonetheless aware of the most recent trends in painting, and therefore able to handle light, shadow, and drapery with considerable skill, or a genuinely sophisticated painter (that is, Raphael) pretending for the occasion to more modest talents and greatly amusing them both.

The panel shows two events. First, at the left, Inghirami is shown seated on his mule, dressed in the black robe and red hat of a Lateran canon, a manuscript in his hands and attractive young students walking beside him. His location is precisely noted: he is just inside the Arch of Titus in the Roman Forum, where he had a *vigna*, a summerhouse with a grape arbor. We can even see the ancient bas-relief on the inside of the arch, showing Titus, the conqueror of Jerusalem, in the triumphal chariot that had traveled through the Forum along this very same Sacred Way in 70 BC. The second scene is in the right foreground, where the ex-voto focuses on the accident, with wild-eyed black oxen barely under control as they lug a cart piled high with sacks of grain. One cartwheel crushes Inghirami's red canon's hat, revealing his bald pate, as his fine black robes splay in the dust. Gold spurs on his boots identify him as a count, and a large ring attests to his wealth.

Tears start from his divergent eyes as his students bend down to help him. Most tellingly of all, however, he clutches his manuscript to his heart (fig. 22)—this is a librarian who will give his life to protect the books in his charge, although this particular book probably comes from his extensive personal library.

The scene has a diabolical cast, from the blazing eyes of the maddened cattle to the panicked carters. Papers bearing mysterious cabbalistic signs have been pasted to the Colosseum, but in the heavens the clouds have parted to reveal a holy triad: Christ the Savior, flanked by Peter and Paul, the patron saints of Rome. The image of Christ, with his purple robe and golden sash, is absolutely specific. It reproduces the mosaic in the apse of the Lateran basilica, for which Jesus, in an epiphany, was said to have posed in person. Peter and Paul also have a special connection with Rome's mother church, for their skulls are preserved above the high altar in an elaborate baldacchino. In the ex-voto, Peter points down to the desperate Inghirami, begging the impassive Savior to spare his faithful canon. The Latin inscription beneath the plaque tells us the outcome: "Thomas Phaedrus to Christ the Savior, snatched from such great danger." One of Inghirami's fellow scholars, Pierio Valeriano, would later report that Inghirami died from complications of this accident, but that, like so many early modern biographical details, may be more fiction than fact. Tommaso lived on for another eight years.[9]

Neither do we know how or when Tommaso Inghirami met Raphael, but a likely meeting place would have been the Apostolic Palace in 1508 or 1509, when the young painter began to execute his frescoes for the papal apartments and Inghirami came and went in the course of his various duties as the pope's librarian, orator, actor, and friend. If playing Queen Phaedra had been Tommaso's ticket to stardom, for Raphael it was these frescoes for Pope Julius. He

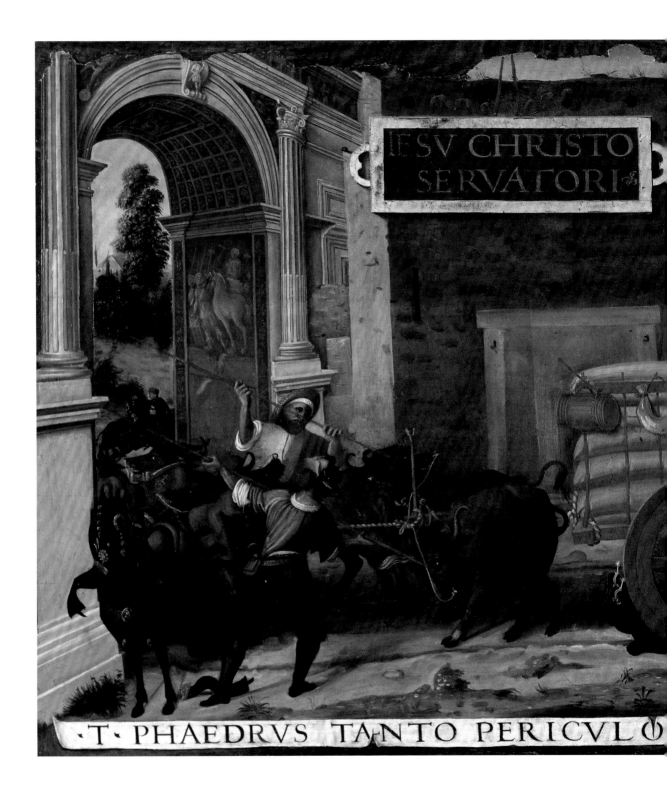

IESV CHRISTO
SERVATORI

·T· PHAEDRVS TANTO PERICVLO

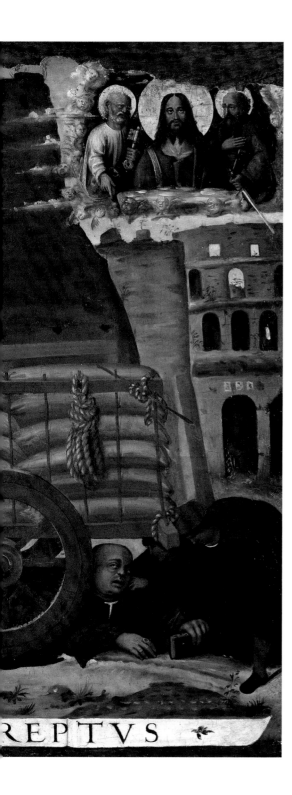

REPTVS

34. Attributed to Raphael, *Ex-voto of Tommaso Inghirami Fallen under an Ox-Cart in Rome*, about 1508. Oil on panel, 64 × 88 cm. Basilica di San Giovanni in Laterano, Musei Vaticani, Vatican City

painted *The Triumph of Theology* in 1508 and *The School of Athens* (fig. 36) from 1509 to 1511. Michelangelo's exactly contemporary frescoes for the Sistine Chapel were thrilling, but Raphael was the artist whose work Julius chose to live with day to day. With this commission, the young painter—winsome, charming, and phenomenally clever—became the darling of Roman society. Inghirami would have been immune to none of these qualities.

The portrait was one of two paintings Tommaso commissioned from Raphael, perhaps to celebrate his appointment as a canon of Saint Peter's and certainly to announce his prominent position in the cultural sphere of Renaissance Rome. In January 1509 Tommaso exchanged his position as a canon of the Lateran for the equivalent post at Saint Peter's, the huge ancient basilica that Julius had decided just two years earlier to raze and replace. The crimson cap and the red alb that Inghirami wears over his black cassock in Raphael's portrait signal his promotion, identifying him as a canon of Saint Peter's (if he were a cardinal, his scarlet vestments would have included the short cape called the mozzetta, and he would certainly be wearing something more opulent than a linen cincture around his ample girth). There was no more expensive dye for early modern fabrics than the red made from crushed cochineal beetles that is also still used for drinks and pastries in Italy. Like their counterparts in the Lateran, canons of Saint Peter's were responsible for the day-to-day life of the basilica, from its religious services to its finances and real estate investments, and by Fedra's time the Vatican had become the real center for papal activity. It was closer to the main inhabited area of early modern Rome, especially to the banking district, and the papal palace was more modern and in better repair than its equivalent at the Lateran.

It was not the first time Inghirami's distinctive face appeared in Raphael's art; since 1509 Tommaso

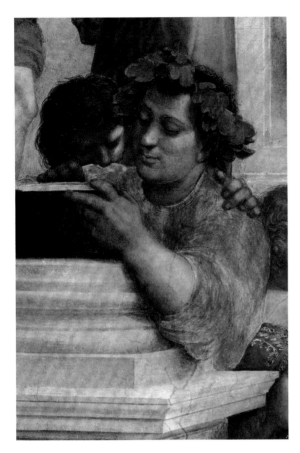

35. Raphael, *The School of Athens*, 1509–11
showing Tommaso Inghirami as Epicurus (detail, fig. 36)

36. Raphael, *The School of Athens*, 1509–11. Fresco,
5 × 7.7 m. Stanza della Segnatura, Stanze di Raffaello,
Vatican Palace

had already occupied a prominent position in the left foreground of Raphael's fresco *The School of Athens*, in the congenial role of the philosopher Epicurus (fig. 35), who declared that philosophical rigor should never interfere with enjoying the pleasures of life. In the same year, 1509, Tommaso also met the Flemish scholar Desiderius Erasmus during the latter's visit to Rome. The two became friends, although Erasmus found the Roman Academy's devotion to Ciceronian Latin simply bizarre and deplored the pope's willingness to put on armor and go to war.

Raphael's portraits almost always show their sitter looking straight at the viewer. There are only three exceptions, and they are notable: the close friend who poses with the artist himself in a late double portrait, Pope Julius II, and Tommaso Inghirami. The friend in the foreground of the double portrait may well be Raphael's pupil Giulio Romano, in which case his glance upward and backward toward his master acknowledges a definite hierarchy within this otherwise reciprocal relationship (fig. 37). The downward glance that Raphael captures on the face of Pope Julius seems, by contrast, to have been a characteristic expression of this complex man (fig. 30); we can see the same oblique, pensive gaze in Botticelli's frescoed portrait of Julius as a cardinal, executed nearly thirty years before on the wall of the Sistine Chapel (in the foreground of *The Temptation of Christ*), and on Michelangelo's unfinished statue for the pope's tomb in San Pietro in Vincoli in Rome. No artist, at least to our knowledge, ever dared to portray Giuliano della Rovere head-on; in full blaze, his eyes must have been as terrifying as his reputation.

Raphael's talent as a portraitist shines through in his sensitive treatment of Inghirami's two most defining physical characteristics. The librarian suffered from a clinical condition known as divergent strabismus (extropia, or walleye), a hereditary trait that still affects

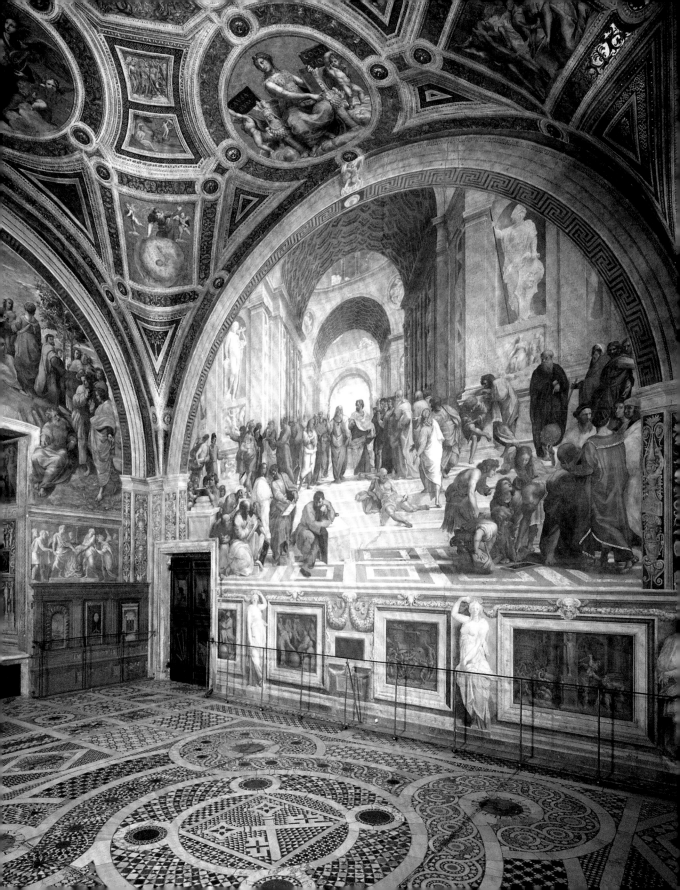

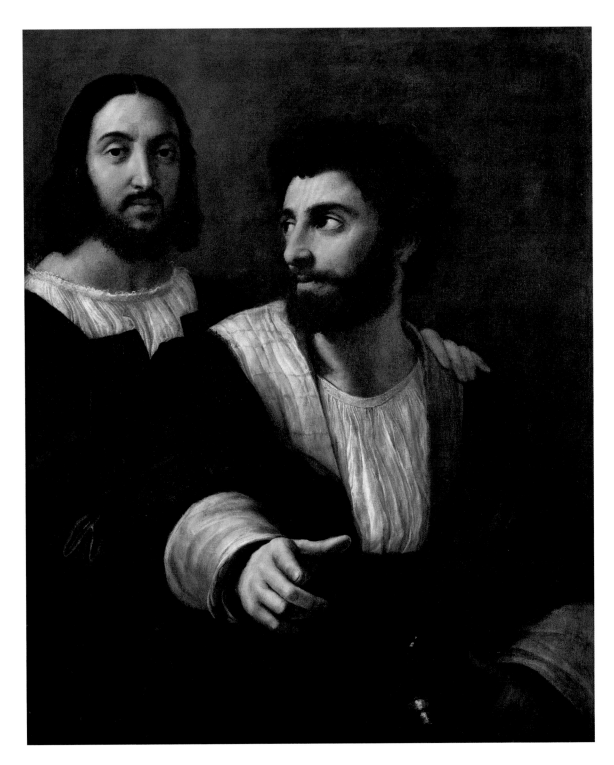

37. Raphael, *Self-Portrait with a Friend*, 1518.
Oil on canvas, 99 × 83 cm. Musée du Louvre, Paris

some present-day members of the Inghirami family.[10] When Tommaso appeared as Epicurus in *The School of Athens*, Raphael dodged the issue by showing his friend engrossed in a book (appropriately enough for the newly appointed prefect of the Vatican Library), but for a formal, frontal likeness he could not avoid it. The painter shows Inghirami's lazy eye but moderates its visual impact by directing his gaze up and away from the viewer. Similarly, the rotund librarian hardly fit the model of the lithe young men familiar to Raphael, and indeed the cleric's corpulence was the subject of contemporary comment. Whereas Rome's literati enjoyed snickering in Latin verse, comparing Tommaso to Mount Etna and referring to him as a "heavy-duty orator" (gravis orator), Raphael presents Inghirami's girth discreetly, suggestive of his scholarly gravitas.[11]

At the time of his portrait, the flamboyant Volterran was just over forty, a man who had attained both wealth and success after a rocky start in life. What Raphael's portrait offers is both a glimpse into his soul and a tribute to his material accomplishments. Tommaso Inghirami left a relatively sparse written record, but one little book, probably used for teaching, provides telling insight into what he thought he had done with his life and his remarkable complement of "heavenly gifts." The book (fig. 38) is a commentary on *The Art of Poetry*, advice in verse penned in 19 BC by Horace, the stout, jolly lyric poet who was a dear friend of both Virgil and Augustus.[12] The most famous line in this influential work is "ut pictura poesis" (poetry is like painting), already a virtual cliché by the early sixteenth century. Yet when taken together, Tommaso's commentary on Horace and Raphael's portrait of Tommaso transform that well-worn phrase into something entirely new.

"Poetry," Inghirami writes, "arises in heaven and was bestowed on humanity by the gods; the inspiration that agitates the poet inspires mortals to greater achievements." He endorses Horace's comparison of art and poetry wholeheartedly:

A painter can rightly compare the art of poetry to painting, because a poet is nothing but a speaking painter and a painter a mute poet. Both of them create faces, ideas, varieties of forms, battles, lines of soldiers, navies, movements of men and beasts. . . . Each of them paints, but the poet does so with greater success, with colors that never fade with time, or weather away, and cannot be destroyed by any force, but rather, like gold, increase in value with age.

Above all, Inghirami argues that poets (and, by analogy, painters) have been granted their talents to carry out a lofty moral mission:

Who can inflame human spirits at will and extinguish their wrath, understand hatred and pain, or soothe them in gentleness and mercy, unless they see into the depths of the reasons that minds act in their different ways, and how human nature and custom develop?

In Raphael's portrait, Fedro turns one eye heavenward, to the origin of poetic inspiration, and the other to a blank sheet of paper. The painter cannot reproduce the orator's extraordinary voice, but he can suggest the process of creation. At nearly the same time, he was painting the wall and ceiling of *The School of Athens* with a line from Virgil, "numine afflatur," a reference to the Sibyl's poetic outburst in the *Aeneid*, "inspired by heaven." Both Raphael and Inghirami would have felt that heaven was generous enough to extend that inspiration to painters: Inghirami's commentary on Horace insists that poetic license applies to artists, too. But that license, he continues,

negligentia ut pictura poesis erit sepe a
nobis dictum, Picturam ee mutum poetam
silentem
~~pictam vero silentem~~ poeta vero silentem pictorem
poetam
rem, nam ut mutam q[uo]q[ue] fingit que
q[uo]q[ue]
regio ora, qui locus gerar, que sp[irit]us firma
que pugna, que acies, quod nemingi[?], eos
motus hominum, qui gerar, no ita ab
Homero expositus e, ut ne apelles qdem
aut parrhasius, melius in oculos ponere
potuerit capiat debebit hec alia pictura
argumenti sapiens rudibus ingeniis doctum
intelligens inueni pisonem non disciplinis
artis doctrina L calpurnij pisonis fing-
ris docuis instituris debi[?] sententia sum[?]
pueritiam tolle aufer eo eadem iniqui-

must be guided by a devotion to truth. Tommaso Inghirami may have been fat, bald, and walleyed, but Raphael's distinctive characterization of him is a detailed portrait of genius.

In 1511 Inghirami's old associate Cardinal Carvajal broke with Julius and, together with a handful of other cardinals, set up a competing Curia in Pisa to elect an alternative pope. Julius responded by excommunicating the group and calling his own church council to meet in Saint John Lateran in 1512. He appointed Tommaso Inghirami secretary of this Second Lateran Council, entrusting all the public announcements and the smooth running of the proceedings to Fedro's stentorian voice, confident, and rightly so, that it would reach to the utmost corners of the vast ancient hall. But age and care, along with a long-standing case of syphilis, were quickly sapping the superhuman forces of that fiercely energetic pope. Julius died with the council still in session, in March 1513, and Tommaso Inghirami delivered his funeral eulogy.

The College of Cardinals was already gathered for the council. Swiftly, they elected Cardinal Giovanni de' Medici, the son of Inghirami's first patron, Lorenzo il Magnifico, who took the name Leo X, thinking in part of the Marzocco, the lion that symbolizes Florence. Five years younger than Tommaso, and like him an early transplant from Florence to Rome, Leo had known Inghirami for decades, and under the pontificate of this very young pope, only thirty-seven, Tommaso's career continued to thrive. When Leo awarded his brother Giuliano honorary Roman citizenship in September 1513, Inghirami arranged the elaborate two-day pageant that accompanied the ceremony. He continued his duties at the Lateran Council, arguing for, and winning, new privileges for the city of Volterra, showing his thanks in yet another public oration. In 1516 his health began to decline as a result of what he called his "yearly disease" (morbus anniversarius). He died in September, leaving behind a few manuscripts, the texts of some of his speeches, and memories of his splendid voice. Because Saint Peter's Basilica had been slated for demolition since 1506, he was buried in Saint John Lateran, where his tomb—perhaps—can still be seen today.[13]

NOTES

1 Raffaele Maffei to Mario Maffei, 19 September 1516, Biblioteca Apostolica Vaticana, MS Vat. lat. 7928, fols. 69v–70r (modern pagination): "Vir profecto cui nature dotes quantas nemini hoc tempore viderim, aut audiverim cumulatim obvenerat . . . ; ingenium innumerato quodammodo habebat, ita ut omnia quae tentaret ei magnopere succederent. . . . Atque utinam haec dona caelestia caeteris artibus in quibus vera est laus ac felicitas coniunxisset, nihil eo beatius." Maffei's "nihil eo beatius" is an extremely refined touch: Cicero's letters also use "nihil" to refer to a person; see Charlton T. Lewis and Charles Short, *A Latin Dictionary* (Oxford, 1879), s.v. "nihil"; and compare Cicero, *Ad Atticum* 1.13, 1.14, 2.24, 10.11, etc. So is his "innumerato," meaning "ready to hand," drawn from Quintilian, 6.3.11.

2 For his role in carrying out this siege on Lorenzo's behalf, the mercenary captain Federico da Montefeltro, count of Urbino, was promoted to the rank of duke. He invested some of the money he made by plunder in his famous library, now housed in the Vatican Library.

3 The fortress is also home to a renowned theater company, the Compagnia della Fortezza, which revived its touring productions in 2004, after its suspension in 1994, when some of the actors were caught reverting to the activity, armed robbery, that had landed them in prison in the first place.

4 Laetus, "Happy," was the illegitimate son of Sanseverino, a Neapolitan prince.

5 Angela Fritsen, "Ludovico Lazzarelli's *Fasti Christianae Religionis*: Recipient and Context of an Ovidian Poem," in *Myricae: Essays on Neo-Latin Literature in Memory of Josef Ijsewijn*, ed. Dirk Sacré and Gilbert Tournoy (Leuven, 2000), 122.

6 Ingrid D. Rowland, *The Scarith of Scornello: A Tale of Renaissance Forgery* (Chicago, 2004).

7 The Inghirami family tree has men named both Fedro and Tommaso Fedra and women named Fedra. The most recent Tommaso Fedra was born in 1992.

8 This was the standard punishment for the range of sexual practices defined as sodomy.

9 Raffaele Maffei commemorates Fedra's death in a letter to his brother Mario of 19 September 1516, Biblioteca Apostolica Vaticana, MS Vat. lat. 7298, fol. 69v.

10 One recent Inghirami uncle could control his wandering eye at will; younger members of the family have corrected the condition with vision therapy. For the heritability of strabismus, see Elizabeth C. Engle, "Genetic Basis of Congenital Strabismus," *Arch Ophthalmol.* 125, no. 2 (2007): 189–95, at https://jamanetwork.com/journals/jamaophthalmology/fullarticle/817192.

11 Two epigrams by Angelo Colocci about Inghirami's obesity, "Ad Leonem de Phedri corpulentia" and "In Phedrum corpulentum," were published in Gianfrancesco Lancellotti, *Poesie Italiane, e Latine, di Monsignor Angelo Colocci* (Jesi, 1772), part 2, "Poesie Italiane," 56, 73.

12 David Rijser makes a convincing case for Inghirami's authorship in "The Tortuous Path from Anonymity to Authorship: MS BAV Vat. Lat. 2742," in *Neo-Latin Philology: Old Traditions, New Approaches*, ed. Marc Van Der Poel (Leuven, 2014), 89–106.

13 The Inghirami tomb in the fourth right-hand chapel of Saint John Lateran is identified as Tommaso's by the official Vatican website, http://www.vatican.va/various/basiliche/san_giovanni/it/basilica/navata_min.htm, but one of the surviving inscriptions dates from 1624 and commemorates Cosimo and Settimio Inghirami, father and son from another branch of the extensive family. An earlier epitaph commemorates two unnamed people as "twin souls."

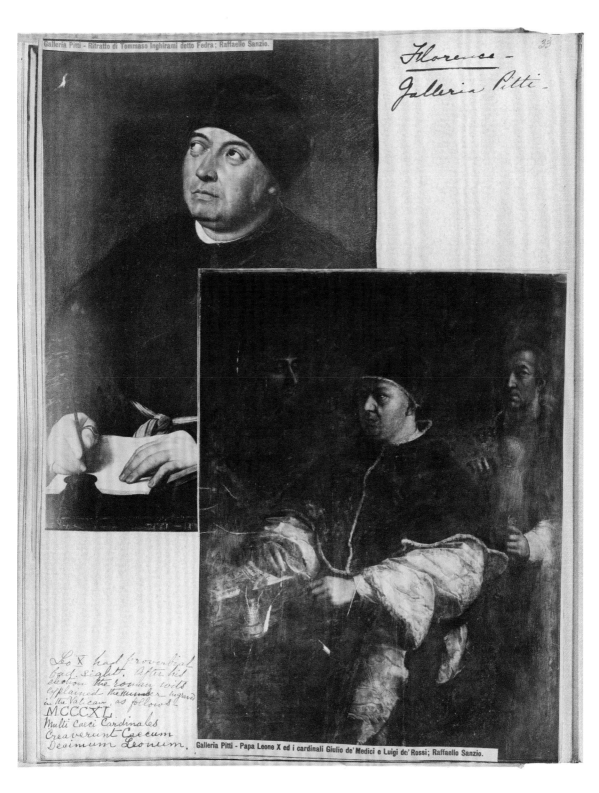

Galleria Pitti - Ritratto di Tommaso Inghirami detto Fedra; Raffaello Sanzio.

Leo X had proverbial
bad sight. After his
election the roman wits
explained the number engraved
in the Vatican, as follows:
MCCCXL
Multi Caeci Cardinales
Creaverunt Caecum
Decimum Leonem.

Galleria Pitti - Papa Leone X ed i cardinali Giulio de' Medici e Luigi de' Rossi; Raffaello Sanzio.

Checklist

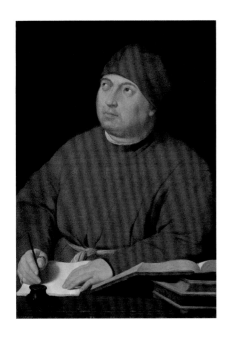

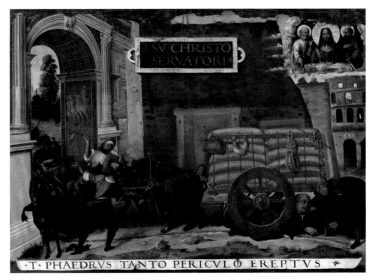

·T· PHAEDRVS TANTO PERICVLO EREPTVS ✦

1

Raphael (Urbino, 1483–1520, Rome)
Tommaso Inghirami, about 1510
Oil on panel
90 × 62.5 cm (35 ⁷/₁₆ × 24 ⁵/₈ in.)
Isabella Stewart Gardner Museum, Boston
(Raphael Room: P16e4)

PROVENANCE
Commissioned after 1509, when Tommaso Inghirami
was made a canon of Saint Peter's, and possibly about
1510, when he was appointed prefect to the Vatican
Library.
Collection of the Inghirami family, Volterra, on
Tommaso's death in 1516 and by descent through male
heirs.
Purchased by Isabella Stewart Gardner from the
Inghirami family in March 1898 for £7,000 ($36,455)
through Bernard Berenson (1865–1959), American art
historian, and the dealer Emilio Costantini, Florence.

2

Attributed to Raphael (Urbino, 1483–1520, Rome)
*Ex-voto of Tommaso Inghirami Fallen under an
Ox-Cart in Rome*, about 1508
Oil on panel
64 × 88 cm (25 ³/₁₆ × 34 ⁵/₈ in.)
Museo del Tesoro, Basilica di San Giovanni
in Laterano, Musei Vaticani

PROVENANCE
Commissioned by Tommaso Inghirami from Raphael
for the basilica of Saint John the Lateran in about 1508.

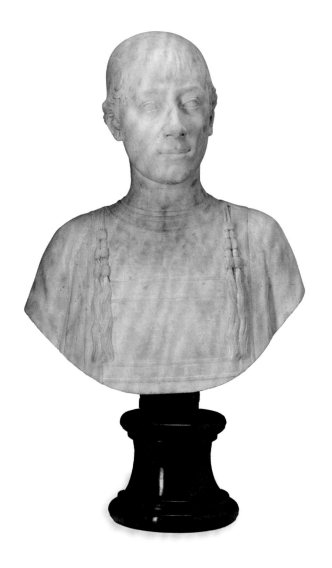

3

Attributed to Andrea Bregno (Ostemo, 1418–1503, Rome)
Cardinal Raffaele Sansoni Riario, about 1478
Marble (formerly partially gilded)
57.2 × 48 × 20.3 cm (22 ¹/₂ × 18 ⁷/₈ × 8 in.)
Isabella Stewart Gardner Museum, Boston
(Long Gallery: S27w71)

PROVENANCE
Likely created after a preparatory terracotta model now
housed in the Staatliche Museen, Berlin (inv. no. 4996) in
about 1478.
Later reused as a bust of a saint, perhaps in San Lorenzo
in Damaso, Rome, Cardinal Riario's (1461–1521) titular
church from 1483 to 1517.
Collection of David Nathan, London, before about 1906.
Purchased by Isabella Stewart Gardner from the picture
dealers Dowdeswell & Dowdeswell, London, for £6,350
on 18 June 1907, through the Parisian picture dealer
Maurice Rosenheim and the British collector and dealer
Joseph Henry Fitzhenry (d. 1913) (as a work by the
Italian artist Andrea del Verrocchio, 1435–1488).
Due to the high cost of import duties, this bust remained
in Europe until 1908 in the care of Mrs. Thomas Lincoln
Chadbourne (Emily R. Crane, 1871–1964).

4

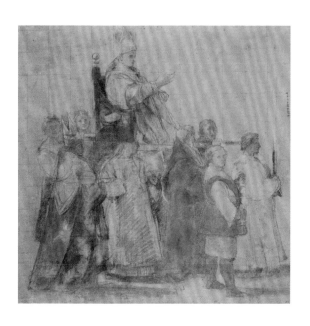

Raphael (Urbino, 1483–1520, Rome)
Procession of Pope Sylvester I, about 1516–17
Colored chalks on paper
39.8 × 40.3 cm (15 $^{11}/_{16}$ × 15 $^{7}/_{8}$ in.)
Isabella Stewart Gardner Museum, Boston
(Short Gallery: 1.1.r.12)

PROVENANCE
Collection of William C. Russell (1800–1884), Accountant
General of the Court of Chancery, London.
Sold at the auction of William C. Russell's collection at
Christie, Manson and Woods, London, on 10 December
1884, lot 457.
Collection of Sir John Charles Robinson (1824–1913),
museum curator, collector, and connoisseur, London.
Purchased by the art dealers Thomas Agnew & Sons,
London, 1901–2.
Purchased by Isabella Stewart Gardner at auction from
the sale of Sir John Charles Robinson's collection at
Christie, Manson and Woods, London, on 12 May 1902
for £50 through Thomas Agnew & Sons, lot 295.

Dining Room.

1. In this room, directly opposite the entrance, in the alcove, hang three celebrated pictures. The centre one of the group is a portrait of Cardinal Inghirami, by Raphael, the replica of which is in the gallery of the Pitti, Florence.

2. On the right is a full length portrait of Phillip IV. of Spain, by Velasquez, who was the greatest of Spanish painters. He was born in Seville, 1599, and died in Madrid, 1660. He was a pupil of Herrera el Viejo and of Francisco Pacheco, whose daughter he married in 1618.

3. On the left of the Raphael is a portrait of Anne of Austria and Child, by Titian.

4. Under the Raphael is a terra cotta of a Madonna and Child, by Jacopo della Quercia.

5. Over the sideboard is a portrait of the Duke of Monmouth, son of Charles II. of England, which was painted by Sustermans.

6. The stained glass windows came from a church in Nuremberg and date back to the fifteenth century.

7. Portrait of a Lady, by Agnola Bronzino, another famous artist of the sixteenth century—Florentine school. He painted some excellent portraits of the Medici family. He was a great admirer of Michel Angelo.

8. Portrait of Isabella D'Este, by Polidoro. A very good example of that artist's work. He was born at Caravaggio, Italy, 1490 ; died in Messina, 1543. He was much influenced in his work by Titian.

5

Isabella Stewart Gardner (New York, 1840–1924, Boston)
Catalogue of 152 Beacon Street, 1899
Printed ink on paper
20.7 × 28.8 cm (8 1/8 × 11 5/16 in.) open
Isabella Stewart Gardner Museum, Boston
(Archives: ARC.008726)

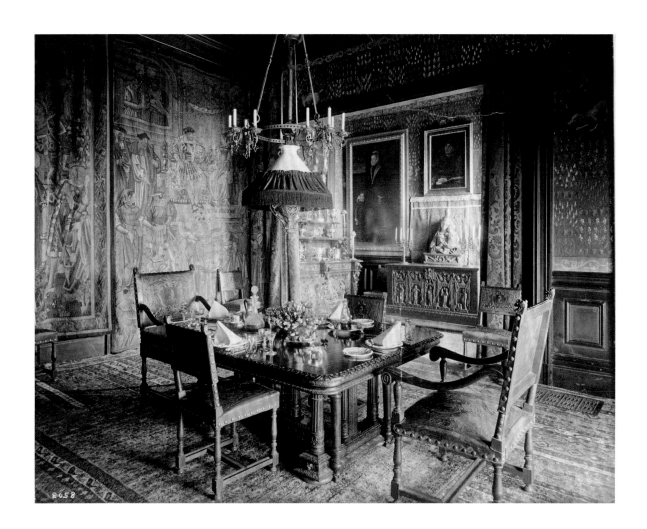

6

Thomas E. Marr and Son (active Boston, 1870s–1954)
Dining Room, 152 Beacon Street, 1900
Gelatin silver print
19.5 × 24.5 cm (7 $^{11}/_{16}$ × 9 $^{5}/_{8}$ in.)
Isabella Stewart Gardner Museum, Boston
(Archives: Marr2058)

PROVENANCE
Commissioned by Isabella Stewart Gardner in 1900.

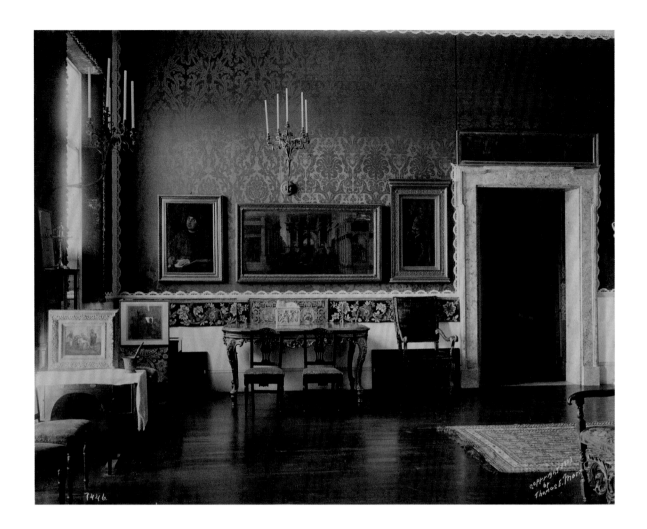

7

Thomas E. Marr and Son (active Boston, 1870s–1954)
Raphael Room, Isabella Stewart Gardner Museum, 1900
Gelatin silver print
30.4 × 35.7 cm (11 $^{15}/_{16}$ × 14 $^{1}/_{16}$ in.)
Isabella Stewart Gardner Museum, Boston
(Archives: Marr7446)

PROVENANCE
Commissioned by Isabella Stewart Gardner in 1903.

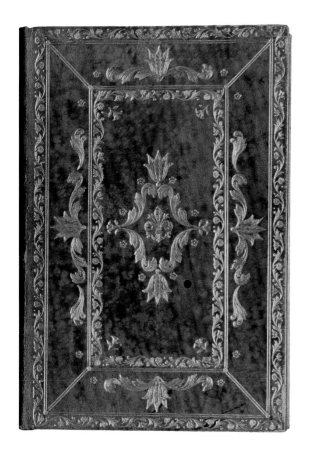

8

Isabella Stewart Gardner (New York, 1840–1924, Boston)
Paintings, Fenway Court, 1917
Ink on paper
48.3 × 34.3 cm (19 × 13 ½ in.) closed
Isabella Stewart Gardner Museum, Boston
(Vatichino: ARC.009109)

THE LATEST WHIM OF AMERICA'S MOST FASCINATING WIDOW

COURTYARD OF THE PALAZZO VECCHIO

Mrs. "Jack" Gardner Has Bought an Italian Palace and Will Ship It to Boston and Set It Up There as an Art Memorial to Her Husband.

HALL OF THE STUFA IN PALAZZO PITTI

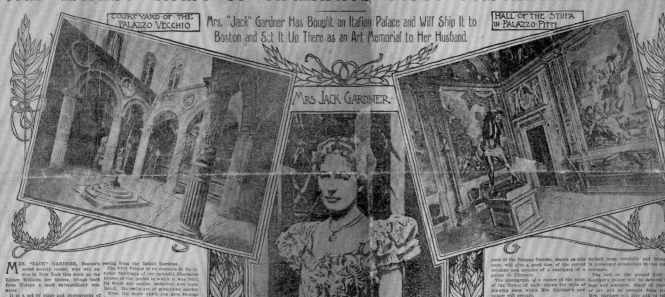

MRS JACK GARDNER

STAIRCASE DEL BARGELLO

TOWER OF GALLO · SALON

THE HALL OF NIOBE, PALAZZO UFFIZI

MRS. "JACK" GARDNER, Boston's noted society leader, who will arrive in New York this week on the Kaiser Wilhelm der Grosse, brings back from Europe a most extraordinary souvenir.

It is a set of plans and photographs of an Italian palace, which she is going to have transported across the Mediterranean and Atlantic and set up in Boston with all its art treasures as a memorial to her late husband.

This quite outdoes all of Mrs. "Jack's" past performances, with which this former New York girl, Isabel Stewart, has been surprising conventional Boston for nearly a score of years.

Last December her multimillionaire husband, Mr. John Lowell Gardner, of Boston, died leaving all his millions to his wife.

She promptly went into the most fashionable mourning. But she really showed her deep sorrow by refraining from doing anything startling for nearly a year.

She went to Europe last June and sought seclusion by hiring a Venetian palace for the season.

It was there that she formed the plan of buying an Italian palace, rich in art treasures and classic in design, and transporting it to her magnificent home.

Cable advices to some of her art-loving friends in this country announced last week, just before Mrs. Gardner sailed for home, that she had succeeded in her project.

She had obtained a palace, built during the Florentine Republic, about four hundred years ago.

This was at the time when Florence was at the height of her prosperity. It was in the Renaissance period, when Florentine art and architecture were the finest in the world.

The Pitti Palace, designed by the famous architect, Brunelleschi, is one of the best types of a Florentine palace, such as Mrs. Gardner has purchased. It was built during the Republic, in the fifteenth and sixteenth centuries. This palace was begun about the year 1440, for Luca Pitti, the head of one of the oldest and most powerful political families of Florence.

The building progressed for twenty-six years, in the slow and substantial way that palaces were then constructed. At that time, in 1466, Luca Pitti's political conspiracy failed against the still more powerful house of the Medici, and Pitti's downfall caused his unfinished palace to fall ultimately into his rival's hands.

Building operations were again begun, but the great structure was not finished till 1549, or 100 years after it was begun.

How thoroughly the work was done is shown now, for after more than four centuries it stands solid and unimpaired. There is every indication that it will endure for a thousand years to come.

The building, which has so successfully defied the tooth of time, has thousands of other art treasures. Few European palaces can equal it in the number of its fine paintings.

To copy any one of these an artist must make application five years in advance, so numerous are the seekers for the privilege. The view of the Pitti Palace is most interesting from the Boboli Gardens.

The Pitti Palace is an example in its interior finishings of the splendid Florentine houses of the period in which it was built. Its floors are mosaic malachite and lapis-lazuli. Its walls are of sculptured marble.

Even the doors which you pass through have frames of variegated marble. The lofty ceilings are covered with paintings framed in gold. Every niche has a statue. One of the noted pieces of statuary is that of Cain and Abel in the Hall of Stufa. There are large wall paintings and pictures in frames throughout the palace done by masters of the Renaissance.

There is a tradition of one of the owners of this palace who lay dying within its walls. A priest endeavored to console him by telling him of the glories of heaven when the dying man exclaimed:

"Father, however glorious it may be, I would rather have the Pitti Palace."

One of the principal features of most Florentine palaces is the courtyard or hollow square in the middle of the building, open to the sky. Round this court are arched colonnades. Fountains play in the centre.

Most of the rooms on the ground floor of the building open out into this court and massive stone staircases rise from it to the second story. The picture of the court-

yard of the Palazzo Vecchio, shown on this page, will give a good idea of the carved columns and arcades of a courtyard of a palace in Florence.

The photograph of a corner of the salon of the Tower of Gallo shows the style of drawing room which Mrs. Gardner's new palace will contain.

The picture of the Hall of Niobe in the Uffizi Palace gives some idea of the appearance of the rooms devoted to statu-

ary and works of art in the palaces of Florence during the period of the Renaissance.

It is a Florentine palace of that age of splendor that Mrs. Gardner is going to bring to America and set up in Boston.

The magnitude of the work may be imagined when it is considered that it is made of huge blocks of stone weighing over a ton each. They are chiselled only at the edges so as to give an increased effect of ruggedness and vastness. All these pieces will have to be numbered as they are taken down so that they may be set up in the same relative position as they now occupy.

There will be many ship loads of the walls and the marbles used in the interior decorations. Besides this the paintings, statuary and furnishings will have to be

packed most carefully and brought in passenger steamships in the care of attendants.

The hall on the ground floor of Gardner's palace will be devoted to tings and statuary. Many of these of art will be brought from Italy. Mrs. Gardner will also add to this tion many choice pieces now in her ton home.

This private museum of art where thrown open to the public. Her own rare apartments will be on the floors.

The location which Mrs. Gardner selected for this palace and museum is located in Boston's fashionable Back district. It will front on the Fens park near the Charles River. This show of the classic proportions of building to the greatest advantage.

Mrs. Gardner already has three opulent homes in Massachusetts. Her town is in Beacon street, Boston, the town house of the Irish aristocracy. She another mansion on a large estate adjoining suburb of Brookline, and country summer home is at Beverly. Mrs. Gardner has had for years only "salon" in the European society, Boston.

Until the death of her husband last year, Mrs. Gardner had her salon afternoon, and every day the brilliant and smart women of Boston gathered informally. Never a dull moment was recorded at those meetings where chic and versatile hostess presided.

Nearly every celebrity that has visited Boston for over a dozen years has been under the spell of this fascinating widow and become a figure at her "afternoon."

She had her literary attractions, Marion Crawford, the novelist, and that "Jack" Crawford, the poet sang musical phenomena, like Paderewski regularly as the Boston theatres had "features."

To be sure Paderewski refused to play at Mrs. Gardner's and play for her but he received his customary price of Bot Mrs. "Jack" had him just the same. She has received the title of "Mrs. Hunter, of America," on account of her fondness for social lions.

But these were only the milder pleasures Mrs. Gardner's eccentricities. She shocked all grades of Boston society by hiring to see Corbett box.

She started the society woman and the bargain-hunting fad in Sandow's muscles.

She went to the Summer "Pop" concert in Boston and drank beer in public.

She borrowed a line from the Boston and paraded it before the public.

She mopped up the steps of a fashionable church on her knees as a penance one Lent.

It was by doing such things that "Jack" has succeeded in giving a freshness and variety to Boston society.

To cap the climax of this long list of achievements needed some great mansion, even for Mrs. Gardner, and she has seen to it.

Her Florentine palace will undoubtedly be the great show mansion of Boston.

HOW TO MAKE SNAKES HARMLESS AND USEFUL.

TWO Baltimore scientists, Dr. Howard A. Kelly and Dr. J. R. Brown, are making a study of the usefulness of snakes and how to cure poisonous snake bites. Dr. Kelly has this to say in behalf of serpents:

"A number of snakes are reported to be poisonous, but are, on the contrary, perfectly harmless, and, indeed, are useful by destroying vast numbers of mice.

"It is folly to destroy harmless snakes for this reason, as well as because of their very evident aid in the destruction of the poisonous varieties, between which and certain varieties of the harmless snakes there is no meaning war.

"Strange to say, the poisonous ones get the worst of it, and are killed by constriction or hugging. The black and king snakes are best active in this regard. The work of giving birds is all right, but I am making a plea for the saving of snakes."

Of the treatment of snake bites Dr. Brown said in a lecture before the Johns Hopkins University Medical School:

"Before the growth of our views regard-

that of Cain and Abel in the Hall of Stufa.

as compresses of the same substance. Alcohol, strychnine and ammonia, the most powerful stimulants, were given by the mouth to counteract the constitutional effects. Some cures were made in this way.

According to its natural meaning, it would seem that a cold was an affection produced by exposure to low temperature, to cold weather. Nothing could very well be farther from the truth than this. Colds are not nearly so readily obtained in cold countries as in the temperate zone. They are not nearly so frequent high up amid the Alps as in the cities at the foot of the mountains. Names, the Arctic explorer, spent over two years amid the Arctic snows, with the temperature so low most of the time the mercury was frozen.

Here Are Some "Dont's" to Prevent Colds.

WE are just entering upon the season when the changeable weather makes colds especially rife.

Did we but know just what a cold is it would surely be easier than it is to secure immunity against it.

in penetrating, or in such small amounts that its beneficial work as nature's great scavenger and germicide cannot be so readily accomplished. Above all, don't sleep in a room where the sunlight and air have not had a chance to do their great work of purification during the day. Even in the Summer time such places are prone to be breeders of disease germs. In the Winter, when microbe life is more luxuriant, such places fairly swarm with microbe organisms. Many of these, of course, are not producers of disease, but then many are.

Don't change very light clothing for heavy clothing all at once. Don't, for instance, change Summer outer and inner garments for Winter ones on the same day. One of the greatest mechanical features connected with the freezing of the

During the Winter so much blood is not sent to the surface, and its heat is retained. Sudden changes in the condition of the skin must be avoided, or the circulation is disturbed, and with it the general health and the ability to resist disease.

Don't wear extremely heavy clothing in the Winter time. Its weight makes it a source of irritation to the skin, which in not merely the external covering of the body. It is not the thickness of clothing nor its weight that protects from cold, but the amount of air it contains in its meshes. Air is a good non-conductor of heat, and so helps us to retain the heat we possess. If an individual is very sensitive to cold it would be better to wear a couple of suits of lighter, thinner woolen underclothing than one very heavy suit. The layer of air between them makes them eminently pro-

YOU CAN NOW CALL UP A "DISTRICT HOUSEMAID"

THERE is a district service of housemaids in town. It opens operations this week and aims at a solution of the question, or puzzling us who hold the Pyramids. How shall we get well trained household service?

The district maid service is the offspring of the prolific Household Economic Association of New York. Mrs. S. Dessan, wife of Dr. S. Henry Dessan, is the originator of the plan. At her home, No. 144 West Eighty-fifth street, and at the headquarters of the Household Economic Association, No. 1775 Broadway, Mrs. Dessan will truly the maids to be deft, polite and efficient. But the instruction will not interfere with the immediate operation of the district service plan.

The servants will assemble at the Household Economic Association's headquarters every morning to await a call. A telephone from a distracted housewife will instantly send one of the maids hurrying to catch the car that will take her to the distracted housewife's relief.

If the call comes at 9 o'clock the maid is ready to do the work of the house,

children out for a walk, or wait upon an invalid in the family, and cook and clean.

The district maid service will be the overburdened women of classes.

The woman whose servant leaves perhaps before breakfast, "without notice."

The woman whose maid has been suddenly ill.

The woman whose baby has the croup.

The woman who "can't keep her servants."

The district service maid can be had for a few hours to tide over in a few of temper or sudden duties cannot endure for weeks and months.

The woman who has had occasion unexpectedly.

The woman whose servant has out for the day and will leave it for reasons or otherwise.

The woman who has had the servant whose friends they were out to them fancy they were Dessan regards this as one of

SELECTED INDEX

PHOTOGRAPHIC CREDITS